ISBN 0901534 82 X

Cover:
Nicolas Poussin, 1593/4–1665,
Landscape with the Ashes of Phocion (No.10350)

CONTENTS

PREFACE

This catalogue, written by Edward Morris and Mark Evans, Keeper and Assistant Keeper of Foreign Art, is a supplement to the Walker Art Gallery's *Foreign Catalogue* of 1977 compiled by Edward Morris and Martin Hopkinson; thus it includes all the foreign works of art acquired by the Gallery since 1977 and a few foreign works of art accidentally omitted from the 1977 Catalogue.

Many individuals and organisations have contributed generously towards the acquisition of the works of art listed in this catalogue. We would like to thank them all. This also affords the opportunity to place on record our particular gratitude to the National Art-Collections Fund, the Pilgrim Trust, the Friends of the Merseyside County Museums and Art Galleries, the Victoria and Albert Museum Purchase Grant Fund and local businesses on Merseyside for their continuing support. The National Heritage Memorial Fund is a new force in the affairs of public art galleries and to them we owe the successful outcome of our negotiations to retain for Merseyside the *Landscape with the Ashes of Phocion* by Nicolas Poussin and the *Virgin and Child with Angels* by Joos van Cleve from two famous local collections, the Earls of Derby at Knowsley, and the Blundells of Ince Blundell. It will also be seen that all major purchases have taken advantage of the tax incentives offered by HM Government to owners selling to public institutions, thus maximising the funds made available by Merseyside County Council. We are also very appreciative of the patience and willingness of vendors in these sales to accommodate our complicated timetable.

Two items, the Elsheimer and the Signorelli drawing, have come through the 'acceptance in lieu' procedure. We are indebted to HM Government for this arrangement, which so enriches collections like ours, and to the Executors for their concern that their treasures should come to Merseyside for the enjoyment of our visitors.

TIMOTHY STEVENS
Director of Art Galleries
Merseyside County Council

NOTES ON THE CATALOGUE

This catalogue follows the format of the Walker Art Gallery, *Foreign Catalogue,* 1977; all dimensions are in centimetres.

CATALOGUE OF PAINTINGS

ADAM, Emil, born 1843

2620 Cherry Lass

Canvas, 81.3×110.2

Signed: *Emil Adam 1905*

Inscribed: *Cherry Lass*

Cherry Lass, a bay filly, was bred by William Hall Walker, later Lord Wavertree in 1902 out of Black Cherry by Isinglass; in 1905, still owned by Walker, she won the One Thousand Guineas, the Oaks and other races, but was beaten in the St. Leger. In most of these races her jockey was Herbert Jones.[1] The jockey in No.2620 wears Hall Walker's colours, blue and white check with a cerise cap. Cherry Lass also appears in Lynwood Palmer's *Brood Mares at Tully, Kildare,* 1913,[2] now in the Walker Art Gallery (No.2612) and in eight watercolours by John Beer also now in the Walker Art Gallery (Nos.2622, 3573–3575, 3581–3582, 3612–3613).

Prov: Bequeathed by Lord Wavertree 1933.

Ref: **1.** See *The Racing Calendar,* 1905, and T. H. Browne, *History of the English Turf,* 1931, pp.25–26, where there is a photograph of Cherry Lass reproduced opposite page 10; in 1905 she won £13,119 for Hall Walker. **2.** This painting is reproduced in *A Gift to the State: The National Stud,* ed. G. A. Fothergill 1916, plate 10.

2664 Count Schomberg

Canvas, 62×80

Signed: *Emil Adam 1901*

Inscribed: *Count Schomberg*

Count Schomberg was a chestnut stallion bred by Colonel Lloyd in 1892 out of Clonavarn by Aughrim.

Count Schomberg is also the subject of a painting of 1892 by N. Arthur Loraine now in the Walker Art Gallery (No.2610).

Prov: Bequeathed by Lord Wavertree 1933.

2665 Mulberry

Canvas, 56.5×68.5

Signed: *Emil Adam 1904*

Inscribed: *Mulberry*

Prov: Bequeathed by Lord Wavertree 1933.

DECAMPS, Alexandre Gabriel, 1803–1860

L 43 Eastern Landscape with Figures and Rider on a Camel

Canvas, 26×33.7

Signed: *DC*

The old attribution was to 'Descamps'.[1]

Prov: John Miller[2]; bought from his daughter by John Patterson; Thomas A. Patterson; Daisy Munn[3]; Miss Margaret Anne Munn who bequeathed it to Wallasey Corporation 1946; lent by Wallasey Corporation 1971.

Ref: **1.** Inscription on the back of L 43. L 43 does not seem to be listed in A. de Moreau, *Decamps et son oeuvre*, 1869 nor in D. F. Mosby, *Alexandre – Gabriel Decamps*, 1977. Dr. D. F. Mosby, *letter* 9 March 1984, suggests that L43 may be by Jean Adrien Guignet. **2.** There were a number of paintings by Decamps in the John Miller Sale, Branch and Leete, Liverpool, 4–6 May 1881, but none can be identified with L 43. **3.** The same inscription (see footnote 1) goes on to read 'Bought at sale at 16 Devonshire Road by Daisy Munn originally in the collection of Mr. John Miller of Liverpool from whose daughter Mr. John Patterson bought it'; another painting in the Munn Bequest to Wallasey (now L 47) has this inscription on the back: 'Bought at Sale of 16 Devonshire Road in Dec. 1926 by Daisy Munn'; Thomas A. Patterson was living at 16 Devonshire Road in 1926.

DELESSARD, Auguste Joseph, born 1827

L 40 House on the Shore, with figure by grounded boat

Canvas, 28×48

Signed: *A. DELESSARD 1851* (or *1861)/NEW YORK*(?)

To judge from his paintings exhibited at the Paris Salon and at various American cities the artist seems to have gone to the United States in 1848–1849 and to have remained there for some years.[1]

Prov: John or Peter Miller[2]; Elfrida Munn; Miss Margaret Anne Munn who bequeathed it to Wallasey Corporation 1946; lent by Wallasey Corporation 1971.

Ref: **1.** In 1860–1862 he was exhibiting pictures at Buffalo and Troy in New York State (James L. Yarnall, *letter*, 25 January 1984). **2.** L 40 does not seem to appear in the John Miller Sale, Branch and Leete, Liverpool, 4–6 May 1881; there were also a number of paintings by Delessard in the John Miller Sale Christie's 20–22 May 1858 (no dimensions given in catalogue).

2

DIEST, Adriaen van, 1655/1656–1704

10245 Landscape with waterfall

Canvas, 182.8×141

Signed: *A V Diest* (initials in monogram)

The artist had settled in England by March 1678 and decorative landscapes by him are common in English collections.[1]

Prov: The Earls of Sefton[2]; presented to the Walker Art Gallery by H.M. Government 1982.

Ref: **1.** There are five landscapes by him in the Royal Collection, see O. Millar, *Tudor, Stuart and early Georgian Pictures in the Collection of Her Majesty the Queen,* 1963, Vol.1, p.158. There are also landscapes by him at Dunham Massey not far from Croxteth Hall, formerly the country house of the Earls of Sefton. Some landscapes are listed in 18th Century inventories of Croxteth Hall but the artists' names are not given. **2.** No.10245 had hung at Abbeystead, near Lancaster, another house owned by the Earls of Sefton, at least since about 1940.

ELSHEIMER, Adam, 1578–1610

10329 Apollo and Coronis

Copper, 17.9×23.0

From the publication of the engraving after this composition by Magdalena de Passe (*c.*1600–1638) in the 1667 Foppens edition of the *Metamorphoses,* until comparatively recently, the subject-matter of No.10329 was wrongly identified as *The Death of Procris.*[1] Its actual subject, *Apollo and Coronis,* is derived from the *Metamorphoses* of Ovid, II, 542–632.[2] Having been informed by a crow of the unfaithfulness of Coronis, Apollo killed her with an arrow (in the left foreground of No.10329). Regretting his anger, the god sought healing herbs in a vain effort to revive her. Directly before the body of Coronis was committed to the funeral pyre (being prepared by the satyrs in the right background of No.10329) Apollo wrenched the unborn child Aesculapius from her womb.

The *Metamorphoses* were extremely popular from Classical Antiquity, through the Middle Ages, to Elsheimer's own day and he is known to have owned a copy of the book.[3] Most previous illustrations of this subject, such as the engraving by Crispyn de Passe the Elder in his series of prints of the *Metamorphoses* (begun by 1602 but apparently not completed before 1604; re-issued in an expanded series with additional text in 1607), depicted the actual shooting of Coronis, with subordinate events from the story sometimes portrayed in the background.[4] Elsheimer's composition is unusual in concentrating attention upon Apollo's futile regret after his fit of jealousy. This implies a careful reading of Ovid's text by the artist. Subsidiary narrative elements (such as the crow and the subsequent birth of Aesculapius) have been suppressed and the subdued attitude of the satyrs around the funeral pyre amplifies

Apollo's remorseful bearing.[5] Earlier illustrations of *The Death of Procris,* such as those by Virgil Solis after Bernard Salomon and by Crispyn de Passe, had similarly portrayed the regret of Cephalus after his shooting of Procris, which may help to explain why the composition of No.10329 was mis-identified as a representation of this scene.[6]

Although Apollo was customarily depicted nude or semi-nude wearing classicising garb Elsheimer portrayed the god wearing a toga-like garment which passes under his right arm and, presumably, over his left shoulder over an under-shirt. Analogous costume often appears in Elsheimer's paintings of saints and angels.[7] The figure of Juno in Hollar's engraving after Elsheimer's lost *Realm of Juno,* which was probably of similar date to *Apollo and Coronis,* also wears bulky, decorated clothing of un-classical appearance.[8] Apollo's toga is decorated with an embroidered strip incorporating a robed figure within a roundel, which recalls the ornate vestments of ecclesiastics in religious paintings by the artist.[9] Apollo's unusual costume may be an additional reason for the subsequent mis-identification of the subject-matter of No.10329, mentioned above.

No.10329 is one of a number of late compositions by Elsheimer, including the *Mocking of Ceres* and *Jupiter and Mercury in the House of Philemon and Baucis,* which illustrate passages from Ovid.[10] It has been pointed out that the composition of Elsheimer's *The Realm of Venus* at the Fitzwilliam Museum, which incorporates a reclining female nude upon a heap of drapery set in a landscape, is analogous with that of No.10329 and that the two pictures are probably of similar date.[11] The background of *Apollo and Coronis,* with an expanse of water within which are reflected trees and beyond which is a tiny figure before a wood, is distinctly reminiscent of Elsheimer's Frankfurt *Tobias and the Angel,* which was engraved in 1608.[12] It has been noted that the figure of Coronis may be a recollection of Titian's prone nude from his Madrid *Bacchanal,* which was in Rome between 1598 and 1621 and could thus have been seen by Elsheimer.[13] There may also be reminiscences of compositions by Altdorfer, whose work Elsheimer encountered during his youth, such as the Berlin *Satyr Family.*[14]

Elsheimer's *Apollo and Coronis* exists in numerous versions, of which Weizsäcker compiled a long list.[15] The majority of these cannot now be traced: The primary versions appear to be: (a) No.10329; (b) Coll. Georg Schäfer, Obbach nr. Schweinfurt, currently on loan to Kunstsammlungen, Stadt Augsburg, oil on copper, 178×230 and (c) Coll. Lt. Col. J. H. S. Lucas-Scudamore, Kentchurch Court, Hereford, oil on copper, 178×231.[16] All three are of excellent quality and include numerous bright flecks of paint in the background foliage, suggestive of beams of light shining through the branches, which do not appear in the other versions.[17] The four others listed by Andrews are: (a) Yale University, New Haven (Inv. 1957.17.1), oil on copper, 178×235, formerly Coll. Dr. A. Jaffé, Berlin; (b) J. B. Speed Art Museum, Louisville (Acc. No.76.17.1), oil on copper, 178×229, formerly Coll. Mrs. Kate Schaeffer, New York; (c) Historisches Museum, Frankfurt (B 59:1), oil on copper, 175×229 and (d) Coll. Dr. Dieter Gescher, Neuilly, oil on copper, 178×228.[18]

There can be no doubt that the original version of *Apollo and Coronis*

was executed by Elsheimer, to whom the composition is attributed in Magdalena de Passe's engraved copy, but it is unclear which (if any) of the known versions is identical with the artist's prototype.[19] Given the brevity of his life and the absence of evidence that he made replicas of his compositions, it seems unlikely that Elsheimer was responsible for more than the original version.[20] This picture (or a close copy) was clearly in the Netherlands by 1638, the terminal date for Magdalena de Passe's engraving, which was dedicated to Elsheimer's old friend Rubens.[21] None of the versions listed above appears to derive from this engraving (which may not have been widely known prior to its 1667 publication), as the composition is reversed in the print. In view of the uniformly high quality of several of the versions, and their common medium, support and approximate size, it seems plausible that more than one of them were executed in the same workshop. Andrews and Waddingham were both of the opinion that, of the known versions of Elsheimer's *Apollo and Coronis*, No.10329 had the best claim to being the original.[22]

Prov: Sir Paul Methuen (1672–1757); inherited by his cousin Paul Methuen[23]; by descent to Paul Ayshford, 4th Baron Methuen; accepted by H.M. Government from the executors of the 4th Baron Methuen in lieu of estate duty 1979; allocated to the Walker Art Gallery by H.M. Government 1982.

Exh: London, The British Institution, 1857, cat. no.102; London, The Burlington Fine Arts Club, *Early German Art*, 1906, cat. no.66; London, Royal Academy, *Exhibition of 17th Century Art*, 1938, cat. no.257; London, Wildenstein, *Artists in 17th Century Rome*, 1955, cat. no.42; Frankfurt am Main, Stadelisches Kunstinstitut, *Adam Elsheimer*, 1966–67, cat. No.35.

Ref: **1.** For the history of this mistaken identification and for other prints, derived from Magdalena de Passe's engraving, of *The Death of Procris*, see I. Lavin, *Cephalus and Procris, Transformations of an Ovidian Myth*, Journal of the Courtauld and Warburg Institutes, vol.17, 1954, pp.285–86. This identification of the subject was accepted by Joachim von Sandrart in his *Academie de Bau-, Bild- und Mahlerey-Künste* of 1675: '... he painted in the same size the wounded and naked Procris, whom Cephalus tries to save through healing herbs. In the distance are field-goddesses, satyrs, fauns, old and young, who kindle a fire in front of the wood'; see K. Andrews, *Adam Elsheimer*, 1977, p.55. **2.** The correct identification was made by E. Holzinger, *Elsheimers Realismus*, Münchner Jahrbuch der bildenden Kunst, vol.II, 1951, p.216. **3.** It is listed in the inventory of possessions drawn up by Elsheimer's widow in 1610; 'Doi altri libri uno della metamorfose d'ovidio ...'; see K. Andrews, *op. cit.*, p.49. **4.** See F. W. Hollstein, *Dutch and Flemish Etchings, Engravings and Woodcuts*, vol.15, n.d., p.287. One of the plates is dated 1602, another 1604. There is a copy of the original edition in the Department of Prints and Drawings at the Victoria and Albert Museum. **5.** Both the crow and the birth of Aesculapius appear in the engravings of this subject by Crispyn de Passe the Elder and an anonymous engraver of *c*.1590, after Hendrick Goltzius. For the former see note 4 above. There is an impression of the latter (Bartsch III, 107, 14) in the Department of Prints and Drawings at the British Museum. **6.** Moreover, in both these versions of *The Death of Procris*, Procris is depicted in a reclining pose with one arm raised and bent over her head, in an attitude generally comparable with that of Coronis in Elsheimer's composition. For the former, see I. Lavin, *op. cit.*, p.287 and pl.43d. For the latter, see note 4 above. **7.** Compare, for example, with the costumes of Elsheimer's *St. Peter* and *St. Paul* at Petworth House, the apostles in his *House-Altar with Six Scenes from the Life of the Virgin* in West Berlin and that of the angel in his Frankfurt *Tobias and the Angel*. See K. Andrews, *op. cit.*, pl.57, 58, 13, 14 and 72. **8.** Both have been dated to *c*.1607–08. See K. Andrews, *op. cit.*, pp.151–52 and pl.79. **9.** Compare, for example, with the costume of the figures in the foreground of Elsheimer's *Exaltation of the Cross* in Frankfurt. See K. Andrews, *op. cit.*, pl.48. **10.** The former at Madrid, the latter at Dresden. Elsheimer's three panels of the realms of Juno, Venus and Minerva, of which the first is lost and the two others are in Cambridge, may also reflect a reading of Ovid. All have been dated to *c*.1607–09. See K. Andrews, *op. cit.*, pp.33–37 and 151–54. **11.** By K. Andrews, *op. cit.*, pp.36 and 151. **12.** For an illustration, see K. Andrews, *op. cit.*, pl.72. **13.** By K. Andrews, *op. cit.*, p.151. **14.** For Altdorfer's influence upon

Elsheimer, see H. Weizsäcker, *Adam Elsheimer der Maler von Frankfurt*, vol.1, 1936, pp.20, 54, 67, 173–74, 206 and 229 and vol.2, 1952, p.129 and K. Andrews, *op. cit.*, pp.17, 20–21, 24–25, 31, 141–42 and 163–64. For Altdorfer's *Satyr Family* of 1507, see *Picture Gallery Berlin Catalogue of Paintings, 13th–18th Century*, 1978, p.19. **15.** See H. Weizsäcker, *op. cit.*, vol.2, 1952, pp.46–48. **16.** See K. Andrews, *op. cit.*, p.151. **17.** These flecks of light which, initially, have the appearance of tinned copper showing through, were commented upon in the context of No.10329 by K. Andrews, *op. cit.*, p.151. Photographs of the Coll. Georg Schäfer and the Coll. Lt. Col. J. H. S. Lucas-Scudamore versions clearly reveal identical flecks of light. The compilers are very grateful to Dr. Keith Andrews and Dr. Gode Krämer for their assistance in the acquisition of photographs of these and other versions of Elsheimer's composition. **18.** See K. Andrews, *op. cit.*, p.151. **19.** The engraving is inscribed *Adam Elsheimer pinxit*. See H. Weizsäcker, *op. cit.*, vol.2, 1952, p.147. **20.** As K. Andrews pointed out, *letter*, 8 August 1983. Rubens, who knew Elsheimer personally and was fond of him, wrote to Johann Faber, after the artist's death, on January 14, 1611: '. . . I hope that God will forgive Signor Adam his sin of sloth . . .' and Karel van Mander observed in 1604 that '. . . he is not very productive . . .'. See K. Andrews, *op. cit.*, pp.51 and 52. **21.** The dedication reads: *Quam zeli peruersa lues . . . suspiciosa meis. V*(iro) *CL*(arissimo) *PETRO PAVLO RVBENIO, ARTIS PICTORIAE HVIVS SAECVLI FACILE PRINCIPI, OMNIUMQ*(ue), *LIBERALIVM ARTIVM AMATORI SVMMO. OBSERVANTIAE SVAE, OB RARISSIMVM EIVS INGENIVM, SIGNVM, HANC A SE AERI INSCVLPTAM TABELLAM D*(at) *D*(onat) *D*(edicat) *Q MAGDALENA PASSAEA CRISP*(ini) *F*(ilia) *FECIT*. See H. Wezsäcker, *op. cit.*, vol.2, 1952, p.147. **22.** The former observed: '. . . *Apollo and Coronis* (of which the best version, if not the master's original) is at Corsham Court . . .' and 'In spite of damages, which Waagen already noticed, the version at Corsham Court is likely to be the original . . .'; see K. Andrews, *op. cit.*, pp.33 and 151. The latter stated: '. . . At least six respectable examples of the *Apollo and Coronis* exist, three contending to be the original. Deciding on the right one – or at least the best version – is an exacting task involving the keenest analysis. In my view, Lord Methuen's painting at Corsham comes nearest to meeting the standards set by the virtually contemporary Petworth series . . .'; see M. Waddingham, *Elsheimer Revised*, Burlington Magazine, vol.114, September 1972, pp.609–10. No.10329 was exhibited at the *Adam Elsheimer* exhibition at Frankfurt in 1966–67, as were the versions in the J. B. Speed Art Museum, Historisches Museum, Frankfurt and Coll. Dr. Dieter Gescher. H. Weizsäcker, *op. cit.*, vol.1, 1936, pp.140–41, had not personally examined No.10329, but he accepted the opinions of Passavant and Waagen, who had, that it was autograph. He was also of the opinion that the versions now in the Coll. Georg Schäfer and Yale University Art Gallery were by Elsheimer. **23.** No.10329 is recorded as in the Grosvenor Street House of Sir Paul Methuen in T. Martyn, *The English Conoisseur*, vol.2, 1766, p.31.

FUSELI, John Henry, 1741–1825

1537 Death of Oedipus

Canvas,[1] 149.8×166.4

No.1537 illustrates lines 1606–1608 of *Oedipus at Colonus* by Sophocles.[2] The Messenger is recounting the death of Oedipus:
'It thundered from the netherworld; the maids
Shivered and crouching at their father's knees
Wept, beat their breast and uttered a long wail[3]
On the left is the extrovert Antigone, on the right the more passive Ismene; the remarkable gesture of Oedipus can be interpreted as his recognition that the thunder signifies his death.[4] Paintings representing scenes from plays by Sophocles are uncommon before the late 18th Century.[5]

The figure of Ismene in No.1537 is largely taken from the same figure in Fuseli's *Oedipus cursing his son Polynices* of 1776–1786[6] (also illustrating *Oedipus at Colonus* but a slightly earlier incident in the play).

There is a preliminary drawing for No.1537 dated June 1783 differing only in details from No.1537.[7]

Cunningham relates the story that Fuseli, when asked of what the 'old man' in No.1537 was afraid, replied, 'Afraid, Sir, why afraid of going to hell!'[8]

Engravings: J. R. Smith, 1785; W. Ward, 1785; Franz Hegi in *Heinrich Fuessli's Samtlichen Werken,* Zurich, 1807 (No.9).

Prov: William Roscoe[9]; his Sale Winstanley's Liverpool, 28 September 1816, lot 155, bought Robinson £27:6:0; Thomas Lawrence Sale Christie's 15 May 1830, lot 53, bought Peacock £21:0:0. E. H. Baily. Presented to the Walker Art Gallery by James Aikin 1876.

Exh: Royal Academy 1784, No.147, as *Oedipus with his daughters receiving the summons of his death;* Suffolk Street, London, 1832, No.21; International Exhibition, London, 1862, No.325.

Ref: **1.** To judge from the prints reproducing No.1537 (see *Engravings*), it has been cut down slightly on both sides. **2.** John Knowles, *The Life and Writings of Henry Fuseli,* 1831, Vol.1, pp.316–317. These lines are inscribed (in Greek) on the preliminary drawing for No.1537 (Christie's Sale 16 July 1974, lot 74, re-pr.). **3.** Sophocles, *Oedipus at Colonus,* Loeb Classical Library, 1932, Vol.1, pp.290–291. The messenger's speech (including lines 1606–1608) is particularly commended by Longinus's *On the Sublime,* ed. Moxon, 1953, p.297. **4.** This analysis follows G. Schiff, *Johann Heinrich Fussli,* 1973, Vol.1, pp.134–135; for Schiff, Oedipus's gesture, also perhaps suggesting pain and self defence, is 'on the borders of the comic,' Schiff's hostile account noting in particular Fuseli's inadequate grasp of natural forms, does not perhaps give the artist sufficient credit for originality; the thunder and lightning is no longer visible in No.1537 and the composition can best be studied in either of the two engravings after it – one is reproduced in Schiff, *op. cit.,* Vol.2, p.160, No.712a. **5.** See D. Irwin, *English Neoclassical Art,* 1966, p.78, for the popularity of Sophocles among English artists in the late 18th Century; The Oedipus plays by Dryden, Corneille and Voltaire do not include the event recorded in No.1537 but subjects from Sophocles were mentioned in J. J. Winckelmann's *Gedanken* of 1755 and in G. E. Lessing's *Laokoon* of 1766 and there were a number of paintings at the Paris Salon from 1785 onwards with subjects from *Oedipus at Colonus* (J. Guiffrey, *Table des tableaux etc exposés aux Salons,* Archives de l'Art français, 1910, Vol.4, p.98). B. Gagneraux's *Oedipe aveugle recommendant sa famille aux dieux,* painted in Rome in 1784, is at the Nationalmuseum, Stockholm (Inv.828). **6.** Schiff, *op. cit.,* Vol.1, pp.90, 94, 442, 647; the painting listed by Schiff as lost is now in the National Gallery of Art, Washington; for further details see C. Haenlein, *A Fuseli Oedipus Lost and Found,* Apollo, 1974, Vol.100, p.34; No.1537 and *Oedipus cursing his son Polynices* may have been conceived as a pair – they are the same size and the figures in them are of the same scale; both eventually were sold to William Roscoe (see Provenance). P. Tomory, *The Life and Art of Henry Fuseli,* 1972, p.96, compares the two daughters in No.1537 with the women in J. L. David's *Oath of the Horatii* of 1785. **7.** Anton Lock Sale Christie's 16 July 1974, lot 74, bought Schickman. **8.** A. Cunningham, *The Lives of the most eminent British Painters,* 1879, Vol.2, p.56. **9.** H. Macandrew, *Henry Fuseli and William Roscoe,* Liverpool Bulletin, 1959–1960, Vol.8, p.22; Roscoe acquired No.1537 in 1791–1792, together with Fuseli's *Oedipus cursing his son Polynices;* see the *Collected English Letters of Henry Fuseli,* ed. Weinglass, 1982, pp.37, 73, 77, 84, 87 for the full text of the correspondence between Roscoe and Fuseli summarised by Macandrew who did not, however, mention Roscoe's letter of 31 January 1812 in which he writes of all his paintings by Fuseli: 'to me these pictures possess a value beyond even their intrinsic merits. They remind me of former days and are associated with some of the pleasantest hours of my life' – quoted in Weinglass, *op. cit.,* p.386.

1538 Milton when a boy instructed by his Mother

Canvas, 91.7×72.4

A variant of *Milton as a Boy with his Mother,* picture No.38 at the artist's Milton Gallery of 1799–1800 and now at the Hotel Euler, Basle; No.1538 was painted in 1799–1800 while the Basle picture is dated by Schiff to 1796–1799.[1] A third version of this composition, large and unfinished, was sold by the artist to a Mr. Cuthbert in March 1800 for 50 guineas.[2]

Milton's education owed no special debt to his mother[3] but Fuseli's did and an autobiographical note is probably present in this painting.[4] Schiff suggested a drawing by Raphael (engraved by Marcantonio) as a possible source for the composition.[5] There is a preparatory drawing for the composition in the Ulster Museum and Art Gallery, Belfast.[6] According to Macandrew, a lost version of Fuseli's *Silence (A Mother with her two Children)* was intended as a companion for No.1538.[7]

Prov: William Roscoe[8]; by descent to Sir Henry Enfield Roscoe who presented it to the Walker Art Gallery 1914.

Ref: **1.** G. Schiff, *Johann Heinrich Fussli,* 1973, Vol.1, pp.522–523, Nos.916 and 917. **2.** H. Macandrew, *Henry Fuseli and William Roscoe,* Liverpool Bulletin, Vol.8, 1959–1960, p.25; Schiff, *op. cit.,* p.184; this version is now lost. **3.** *The Life Records of John Milton,* ed. J. M. French, 1949, Vol.1, pp.20ff. **4.** Schiff, *op. cit.,* p.219, further arguing that the mother in Fuseli's painting resembled Fuseli's wife and with a long description and analysis of the composition. **5.** Schiff, *op. cit.,* p.219; the Raphael drawing is O. Fischel, *Raphaels Zeichnungen,* 1913–1972, No.375. **6.** Schiff, *op. cit.,* p.542, No.1031. **7.** Macandrew, *op. cit.,* pp.25, 48, but Schiff, *op. cit.,* p.522, does not seem to accept it as a companion to No.1538. **8.** Macandrew, *op. cit.,* pp.25–26, 36; H. Macandrew, *Selected Letters from the Correspondence of Henry Fuseli and William Roscoe of Liverpool,* Gazette des Beaux Arts, 1963, pp.219–220; Roscoe received No.1538 in November 1800 and it was priced at 25 guineas; Fuseli seems to have suggested that No.1538 might be hung over bookshelves in a library and he described it, together with some other pictures, as 'highly finished, portable, fit for any room and most of them interesting and not too deep subjects'. See the *Collected English Letters of Henry Fuseli,* ed. Weinglass, 1982, pp.207, 213, 216, 221, 224 for the full text of the correspondence between Roscoe and Fuseli summarised by Macandrew; for Roscoe's final judgment on his paintings by Fuseli see above p.7, *Death of Oedipus,* footnote 9.

1539 The Return of Milton's Wife

Canvas, 87.5×111.2

Milton married Mary Powell in 1643 but she left him soon afterwards partly because she came from a Royalist family; after the defeat of the king she returned to Milton in 1645[1]; Fuseli's source was probably the life of Milton by his friend William Hayley[2]: 'While he (Milton); was conversing with a relation whom he frequently visited in St. Martin's Lane, the door of an adjoining apartment was suddenly opened: he beheld his repentant wife kneeling at his feet, and imploring his forgiveness.' The two figures in the background of No.1539 would be Mr. Blackborough and his wife who arranged the reconciliation at their house in St. Martin's Lane.[3] Schiff suggests a debt to Greuze in No.1539 particularly in the way Milton's wife grasps the poet's hand.[4]

Prov: William Roscoe[5]; by descent to Sir Henry Enfield Roscoe who presented it to the Walker Art Gallery in 1914.

Ref: **1.** The early lives of Milton recording this episode are reprinted in *Life Records of John Milton.* ed. J. M. French, 1949, Vol.2, pp.118–119. **2.** W. Hayley, *The Life of Milton*, 1796, p.91; Hayley argues that this incident in Milton's life inspired that part of *Paradise Lost* describing Adam's forgiveness of Eve after she had eaten the forbidden fruit; No.1539 may therefore have been intended to parallel pictures 20 and 21 in Fuseli's *Milton Gallery* which illustrate that event in *Paradise Lost.* **3.** *Life Records, op. cit.,* p.119. **4.** G. Schiff, *Johann Heinrich Fussli*, 1973, p.220, also with a considerable description and analysis of No.1539. **5.** H. Macandrew, *Henry Fuseli and William Roscoe*, Liverpool Bulletin, 1959–1960, pp.25–26, and H. Macandrew, *Selected Letters from the Correspondence of Henry Fuseli and William Roscoe of Liverpool*, Gazette des Beaux Arts, 1963, p.219; Roscoe received No.1539 in November 1800 and it was priced at 30 guineas; Fuseli described No.1539 and a number of other pictures as 'highly finished, portable, fit for any room, and most of them interesting and not too deep subjects'. See the *Collected English Letters of Henry Fuseli,* ed. Weinglass, 1982, pp.213, 222, 224 for the full text of the correspondence between Roscoe and Fuseli summarised by Macandrew; for Roscoe's final judgment on his paintings by Fuseli see above p.7, *Death of Oedipus,* footnote 9.

GOTLIB, Henryk, 1890–1966

9273 Italian Landscape with Woman, Child and Dog

Board, 30.5×21.2

Signed: (lower right) *GOTLIB*

In Mrs Gotlib's ms. catalogue of the artist's works, No.9273 has the catalogue number 34 and has been dated to 1960.[1] One of a number of paintings of women and children, often with a Mediterranean setting, executed during the earlier 1960's.[2]

Prov: In the artist's studio on his death, inherited by his widow, Mrs Janet Gotlib from whom purchased, as a lot together with 9274–9280, January, 1978.

Exh: Scottish National Gallery of Modern Art, *Henryk Gotlib 1890–1966*, 11 July–9 August 1970, cat. no.26.

Ref: **1.** Janet Gotlib, *letter* of 30 November 1977. **2.** For examples, see: *Recent Paintings by Henryk Gotlib,* Crane Kalman Gallery, 31 October–23 November 1963, cat. nos.3–11, 13, 19–21, 26 & 28 and *Henryk Gotlib 1890–1966*, Scottish National Gallery of Modern Art, 11 July–9 August 1970, cat. nos.37, 39, 40, 43, 46 & 48.

JOOS van Cleve, active 1511–1540/41

9864 The Virgin and Child with Angels

Oak panel, 85.5×65.5

Inscribed: (on canopy) *PVLCRA ES ET SVAVIS*[1]

The top right and top left corners of No.9864 have been renewed with triangular additions and the top edge of the panel has been trimmed.[2] With the exception of a few irregular scratches which have been repainted, mainly on the figure of the Virgin, the surface is in an excellent state of preservation.

No.9864 has the appearance of the central panel of a triptych. Its wings may be identical with a pair of panels of *St. Catherine* and the *Magdalene* now in a Belgian private collection.[3] The patterned floor of alternating pink and white and blue and white tiles and the grey brick wall with a moulded lip appears in these wings, as in No.9864. It seems that No.9864 originally had a curved ogival top, as did the wings.[4]

Waagen first attributed No.9864 to the Master of the Death of the Virgin, an artist who is now usually identified as Joos van Cleve.[5] The close association of No.9864 with the two triptychs of the *Death of the Virgin* is confirmed by the unusual pattern of the cloth beneath the Virgin's feet, which is a modified version of the pattern which appears on the cloths draped over the donors' *prie-dieu* in the inner wings of these altarpieces.[6] *The Death of the Virgin* altarpieces were commissioned by the Hackney family of Cologne and the version in the Wallraf-Richartz-Museum bears the date 1515.[7] Baldass was of the opinion that No.9864 should be dated to c.1520, whereas Friedländer suggested the rather later date of c.1525.[8] Baldass observed that the other work attributed to Joos with which the composition of No.9864 is most closely comparable is the central panel of a triptych of the *Virgin Enthroned* now at Vienna.[9] Friedländer noted that the pose and the drapery of the angel holding a sheet of music at the right of No.9864 are analogous with those of a lute-playing angel in the central panel of the *Morrison Triptych*.[10] Valentiner interpreted this similarity as an indicator that Joos was trained by the Master of the Morrison Triptych.[11] Baldass pointed out that the central panel of a triptych by a follower of Joos now at Bonn is a variant of that of the *Morrison Triptych* and also includes a lute-playing angel.[12] Although this figure has the wings and the lute of the angel from the *Morrison Triptych*, it is otherwise almost identical with the angel at the right of No.9864. The Bonn altarpiece is not of outstanding quality, but it may be a copy of a lost altarpiece by Joos, painted after the *Morrison Triptych* but before No.9864. Koch noted that the landscape background of No.9864 is virtually identical with that which appears in the *Rest on the Flight* at Brussels, also attributed to Joos and that both landscapes appear to have been appropriated directly from a work by Patinir, probably the *Landscape with Rest on the Flight* in the Thyssen collection.[13] Landscape backgrounds probably copied from Patinir appear in other works by Joos.[14] The presence of such a direct borrowing suggests that No.9864 was not painted earlier than 1515, the year in which Patinir entered the Antwerp guild.[15]

Still lives, such as that on the little table in No.9864, also appear in a number of versions of the *Holy Family* attributed to Joos.[16] The carafe of wine, the bunch of grapes and the cherries all have eucharistic connotations, whereas the apple which the Child is holding symbolizes original sin.[17] Although the lemon is a symbol of the Virgin, the cut lemon and knife may allude to the weaning of Christ.[18]

Prov: Acquired by Charles Blundell 1835–37[19]; by descent to Col. Sir Joseph Weld, from whom purchased, 1981 by the Walker Art Gallery with the aid of contributions from the Victoria and Albert Museum Grant Fund, the National Heritage Memorial Fund, the National Art-Collections Fund, the Special Appeal Fund and other benefactors.

Exh: London, Royal Academy, *Exhibition of Works of the Old Masters*, 1884, cat. no.279,

as the Master of Cologne; London, Guildhall, *Loan Collection of Pictures,* 1892, cat. no.51, as Stephan Lochener; London, Guildhall, *Exhibition of Works by the Early Flemish Painters,* 1906, cat. no.51, as Early Flemish School; London, Royal Academy, *Flemish Art 1300–1700,* 1953–54, cat. no.84; Bruges, Groeninge Museum, *L'Art Flamand dans les Collections Britanniques et la Galerie Nationale de Victoria,* 1956, cat. no.38; Liverpool, Walker Art Gallery, *Pictures from Ince Blundell Hall,* 1960, cat. no.47; Manchester, City Art Gallery, *Works of Art from Private Collections,* 1960, cat. no.4; Bournemouth, Russell-Cotes Art Gallery and Museum, *Paintings from Lulworth Castle Gallery,* 1967, cat. no.88.

Ref: **1.** This text is a conflation of parts of two verses from the Vulgate version of the Song of Songs: Cap.4, v.7 and Cap.6, v.3 (pointed out by Father F. J. Turner, S.J., *letter,* 26 June 1981). **2.** The piece added at the top right extends from the corner 16.1 cm. down the side and 17.5 cm. across the top. The piece added at the top left extends from the corner 16 cm. down the side and 17 cm. across the top. **3.** See: M. Evans, *An early altar-piece by Joos van Cleve,* The Burlington Magazine, Vol.124, 1982, pp.623–24. Also attributed to Joos van Cleve, it has been suggested that these wings date from c.1518. See: M. J. Friedländer, *Early Netherlandish Painting,* Vol.9, *Joos van Cleve, Jan Provost,Joachim Patenir,* 1972, pt.1, cat. no.22 and pl. no.46. These panels have been joined together to form a single picture. Their individual measurements are: height: 81 cm. (inner edge when closed) and 75 cm. (outer edge when closed); width: 29 cm. (bottom edge) and 18 cm. (upper edge). (Information provided by R. Finck, *letter,* 25 June 1981.) The wings have also been trimmed at the top. **4.** Owing to the cutting, it is not possible to gauge the original pitch of this curve. **5.** See G. Waagen,. *Treasures of Art in Great Britain,* Vol.3, 1854, p.250, as 'By that admirable Cologne master who painted the Death of the Virgin in the Gallery at Munich . . .'. For the identification of Joos as the Master of the Death of the Virgin, see M. J. Friedländer, *Van Eyck to Breugel,* Vol.2, 1969, pp.87ff, and *Early Netherlandish Painting,* Vol.9, *Joos van Cleve, Jan Provost, Joachim Patenir,* Pt.1, pp.17ff. and Pt.2, pp.128–29. Some doubts about this identification have been expressed, see M. Davies, *National Gallery Catalogues, Early Netherlandish School,* (3rd. ed. revised), 1968, p.69 and E. Panofsky, *Early Netherlandish Painting. Its Origins and Character,* Vol.1, 1958, p.354. **6.** These two altarpieces are at Cologne (Wallraf-Richartz Museum, No.442) and Munich (Alte Pinakothek, Nos.55–57). The designs consist of strips of hawks attacking rabbits amid flowers, stags and decorative borders. Similar patterns do not appear in any of Joos's other surviving works. In No.9864, the diagonal hatching on the material and the absence of visible pile indicates that a woven cloth, rather than a carpet, is portrayed. Draped over a *prie-dieu* such material is a normal accessory. Placed on the floor it serves as an unusual substitute for a carpet. It therefore seems likely that the design was originally intended for the *Death of the Virgin* altarpieces and was subsequently re-used in the *Madonna and Child with Angels.* To my knowledge, the similarity between the design of the cloths in the altarpieces at Cologne and Munich and that in the *Madonna and Child with Angels* was first pointed out by D. De Marly, *A Note on the Metropolitan Fortune Teller,* The Burlington Magazine, 112, June 1970, p.388ff. She also observed that the old woman at the right of the *Fortune Teller,* attributed to Georges de la Tour, at the Metropolitan Museum of Art, is wearing a mantle of material with the same pattern. D. King, *The Metropolitan Fortune Teller,* The Burlington Magazine, 112, October 1970, p.700ff., pointed out that a piece of woven fabric with a design similar to that depicted by Joos van Cleve is preserved in the Erzbischöfliches Diözesan-Museum at Cologne. H. Schmidt, *Alte Seidenstoffe,* 1958, p.254, recognised the similarity between this textile and that depicted in the wings of the Cologne *Death of the Virgin.* He suggested that the former might be of Venetian origin. According to the exhibition catalogue *Von der Faser Zum Stoff,* Historische Museen der Stadt Köln, Kölnisches Stadtmuseum, October 1975–March 1976, cat. no.62, p.52ff., the textile was produced at Cologne during the fifteenth century. The Cologne textile measures 226 cm. by 185 cm., and has been described as a church wall hanging. It appears to be sufficiently large to serve as a *prie-dieu* cover, such as is depicted in the wings of the two versions of the *Death of the Virgin.* **7.** This date has been renewed. The Hackneys were a patrician family and generous patrons of the arts. In addition to the Cologne and Munich versions of the *Death of the Virgin,* which were respectively commissioned for their palace on the Neumarkt and the church of St. Maria im Capitol, they endowed other Cologne churches with altarpieces in c.1500 and c.1523 and commissioned a new rood-loft for St. Maria im Capitol in 1523. See G. Matthes, *Der Lettner von St. Maria im Capitol zu Koln von 1523,* PhD dissertation, University of Bonn, 1967, pp.9–12. **8.** See L. Baldass, *Joos van Cleve,* 1925, p.21, and M. J. Friedländer, *Early Netherlandish Painting,* Vol.9, *Joos van*

Cleve, Jan Provost, Joachim Patenir, Pt.1, p.65. **9.** L. Baldass, *op. cit.,* p.19. The central panel of this triptych (Kunsthistorisches Museum, E.1001. Inv.-Nr.938) measures 94.5×70 cm. It has been suggested that it dates from *c.*1520. See M. J. Friedländer, *Early Netherlandish Painting*, Vol.9, *Joos van Cleve, Jan Provost, Joachim Patenir*, Pt.1, pp.54–55. **10.** With the exception of this angel the *Morrison Triptych* (Museum of Art, Toledo, Ohio, Acc. No.54.5A–C) is an approximate copy after Memling's *St. John Altarpiece* at Vienna. See M. J. Friedländer, *Early Netherlandish Painting*, Vol.7, *Quentin Massys*, 1967, p.42. **11.** See W. R. Valentiner, *Simon van Herlam The Master of the Morrison Triptych*, Gazette des Beaux Arts, Vol.45, 1955, p.10. **12.** Rheinisches Landesmuseum Bonn, G.K. 1927, Nr.142. See: L. Baldass, *op. cit.,* n.61. **13.** See R. A. Koch, *Joachim Patinir*, 1968, pp.52–53 and figs.12–15. **14.** See R. A. Koch, *op. cit.,* p.52 and figs.70 and 72. **15.** Although it has been suggested, without documentary proof, that Patinir was in Antwerp before 1515. See R. A. Koch, *op. cit.,* p.54. **16.** For examples, see M. J. Friedländer, *Early Netherlandish Painting*, Vol.9, *Joos van Cleve, Jan Provost, Joachim Patinir*, Pt.1, pp.64–65 and pls.80–85. **17.** See M. Levi D'Ancona, *The Garden of the Renaissance*, 1977, pp.159ff. and 89ff., and E. Guldan, *Eva und Maria*, 1966, pp.108–116. **18.** F. Grossmann identified this fruit as a pomegranate, symbolic of the Resurrection. See *Works of Art from Private Collections in the North West of England and North Wales*, City Art Gallery, Manchester, 1960, cat. no.4. The fruit looks more like a lemon, such as clearly appears in the painting of the *Holy Family*, attributed to the Master of the Death of the Virgin at the National Gallery, London (Inv.2603). See M. Davies, *op. cit.,* p.102 and n.8. **19.** Col. Sir Joseph Weld (*letter*, 16 June 1981) states that 9864 was acquired by Charles Blundell in 1835–41. Blundell died in 1837.

LASZLO, Philip Alexius de, 1869–1937

10242 Hugh William Osbert Molyneux, 7th Earl of Sefton (1898–1972)

Canvas, 89.5×67.3

Signed: *1921 De Lazlo*

In 1921 the Army List described the sitter as a Lieutenant in the Royal Horse Guards, a regiment he joined in 1917. A photograph of No.10242 is stuck into one of the undated albums of photographs of the artist's sitters now in the National Portrait Gallery.[1]

Prov: Presented to the sitter by the tenants and employees of the Croxteth Estate[2] in 1921 on his Coming of Age[3]; presented to the Walker Art Gallery by H.M. Government 1982.

Ref: **1.** Laib's original negative for this photograph is now in the Witt Library, University of London (No.10255, Box 529). **2.** Croxteth Hall near Liverpool was the principal seat of the family until 1972 when, on the death of the sitter, it passed eventually to the Merseyside County Museums. **3.** In fact he came of age in 1919.

10243 Hon. Cecil Richard Molyneux (1899–1916)

Canvas, 92×71

Signed: *Philip de Lazlo/1915. 1 July*

The sitter was the younger son of the 6th Earl of Sefton and was killed at the Battle of Jutland in 1916 while serving as a midshipman in Admiral Beatty's flagship H.M.S. Lion; he was then not quite sixteen and a half years old. In No.10243 he wears the uniform of a naval cadet[1]; he became a midshipman in September 1915. A photograph of No.10243 is stuck

into the 1913–1915 album of photographs of the artist's sitters now in the National Portrait Gallery (page 97).[2]

Prov: By descent to the 7th Countess of Sefton; presented to the Walker Art Gallery by H.M. Government 1982.

Exh: ? Liverpool Autumn Exhibition 1915 (¶1200) as *Lord Molyneux*.[3]

Ref: 1. Roger Quarm, *letter,* 16 November 1983. 2. Laib's original negative for this photograph is now in the Witt Library, University of London (No.7835, Box 5). 3. The Liverpool Autumn Exhibitions were among the few places still admitting the artist's portraits in 1915 as he was Hungarian by birth – see O. Rutter, *Portrait of a Painter,* 1939, pp.305ff.

LIPCZINSKY, Albrecht, 1875–1974

10296 Canon J. T. Mitchell (1863–1947)

Canvas, 92.0×71.1

Signed: *Albert Lipczinski 1914*

Inscribed: (on stretcher, top) *Canon John Thomas Mitchell Wavertree February 1914* (label on back of frame) *No 1 The Revd. Canon J. T. Mitchell/Albert Lipczinsky/64 Back Roscoe St./Liverpool*

Lipczinsky exhibited at the Liverpool Autumn Exhibitions between 1906 and 1911 and at the Sandon Studios Society between 1911 and 1913 and in 1925. Three drawings by Lipczinsky are in the collection of the Walker Art Gallery.[1] In June 1914 Lipczinsky had an exhibition at the Little Gallery in Great Marlborough Street.[2] Shortly after the outbreak of the First World War, he was interned at a camp near Chester, from which he was released on the initiative of Prof. Charles Reilly.[3] By 1936 he and his wife had returned to Gdansk, where he died.[4]

Canon John Thomas Mitchell was a graduate of Corpus Christi, Oxford and held curacies in West Ham, Bexley and Leeds before becoming Rector of Wavertree in 1894; a post which he held until his retirement in 1947.[5] From 1933 until 1938 Canon Mitchell was residentiary canon of Liverpool Cathedral; he was also Rural Dean of Childwall, honorary chaplain to the Bishop of Liverpool and a Proctor in Convocation. An amateur artist, he exhibited at the 17th annual exhibition of the Society of Parson Painters in 1946.[6]

Prov: Canon J. T. Mitchell, inherited by his daughter Miss H. Mitchell, by whom presented to the Walker Art Gallery, June 1981.

Ref: 1. Walker Art Gallery, *Foreign Catalogue,* 1977, p.257 (inv.8802–8804). 2. *The Athenaeum,* June 13, 1914, p.833. 3. R. F. Bisson, *The Sandon Studios Society and the Arts,* 1965, p.101. 4. Mrs. A. E. Jamouneau, *letter,* December 17, 1976. 5. Obituaries; *Liverpool Daily Post,* August 7, 1947 and *Evening Express,* August 6, 1947. 6. *Evening Express,* November 4, 1946.

MONTAGNA, Bartolomeo, *c.*1440–1523

9375 The Virgin and Child with a Saint

Poplar panel, 37.8×36.5

In an excellent state of preservation. The background of No.9375 was obscured by black paint until cleaned by Professor Cavenaghi, presumably in about 1887.[1]

The attribution of No.9375 to Montagna has been universally accepted since it was first proposed in 1891.[2] Suggested dating ranges from c. 1483 to c. 1499.[3] Affinities have been pointed out between No.9375 and Montagna's *Virgin and Child with Sts. Monica and Mary Magdalene* at the Museo Civico, Vicenza, which has been variously dated between 1480 and 1490,[4] his altarpiece of the *Madonna and Child Enthroned* at the Brera, Milan, signed and dated 1499[5], and a small panel of the *Virgin and Child* at the Ashmolean Museum, Oxford.[6] Other comparative works attributed to Montagna may be briefly listed: a small panel of the *Virgin and Child* in the Scuola di San Rocco, Venice (for the general pose and facial type of the Virgin and for her position, with a low, narrow parapet before and a wider, higher parapet behind); the altarpiece of the *Virgin and Child Enthroned with Sts. Onuphrius and John the Baptist* in the Museo Civico, Vicenza (the Christ-Child is a variant of the figure in No.9375) and a small panel of the *Virgin and Child* in the Art Museum, Springfield (for the motif of a faceted, rocky hillside with a huge hole through the centre, similar to that which appears at the right of No.9375).[7]

The earliest recorded identification of the suppliant at the left as St. John the Baptist is plausible and has secured a considerable measure of support.[8] Hill noted a facial similarity between this figure and Francesco Gonzaga the great general and ruler of Mantua.[9] This identification, which has secured a certain degree of support, seems fanciful.[10] The suppliant wears a halo, which is apparently original, and beneath his cloak is visible a coarse garment, similar to the hair shirt normally worn by St. John the Baptist. Other approximately contemporary representations of a half-length Virgin and Child with an adult figure of St. John the Baptist in supplication include a panel in the Galleria Doria-Pamphili in Rome, attributed to Niccolo Rondinelli and Giovanni Bellini, and a series of variants of a lost Giovanni Bellini composition.[11] The motif of St. John kissing the Christ-Child's foot is unusual and may derive from a half-length representation of the *Adoration of the Magi,* in which the oldest king is sometimes depicted in similar activity, such as the painting attributed to Francesco da Santa Croce in the Pinacoteca Querini-Stampalia, Venice.[12]

Prov: Countess Sparieri-Beltrame of Verona; from whom purchased by Dr. Ludwig Mond in 1887[13]; by whom given(?) to Henriette Hertz by 1891[14], from whom apparently acquired back by Dr. Ludwig Mond[15]; from whom inherited by Alfred Mond, first Baron Melchett; his widow Violet, Lady Melchett sold Sotheby's, 6 March, 1946 (lot 110); bought F. A. Drey £8,200; Sir Thomas Merton; bought from the executors of Sir Thomas and Lady Merton 1978 with the assistance of contributions from the Victoria and Albert Museum Grant Fund, National Art-Collections Fund, the Pilgrim Trust, the Special Appeal Fund and the Mayor Bequest.

Exh: London, Royal Academy, *Works by the Old Masters,* 1891, cat. no.156; London, New Gallery, 1894–95, cat. no.78; London, Royal Academy, *Italian Art and Britain,* 1960, cat. no.340.

Ref: **1.** C. J. Ffoulkes, *L'esposizione dell'Arte Veneta a Londra,* Archivio storico dell' Arte, 1895, p.248. **2.** J. P. Richter, *The Mond Collection,* 1910, p.xii, states that he attributed No.9375 to the School of Verona when he saw it in the collection of the

Countess Sparieri-Beltrame in 1885. It is attributed to Montagna in the catalogue of the 1891 Royal Academy exhibition. **3.** B. Berenson suggests c.1488, in *Venetian Painting in America*, 1916, p.178. A. Venturi, *Storia dell'Arte Italiana*, Vol.7, Part 4, 1915, p.465, suggests slightly earlier than the Milan *Madonna and Child Enthroned*, which is dated 1499. T. Borenius, *The Painters of Vicenza*, 1909, p.23, accepted Berenson's dating. R. De Suarez, *Bartolomeo Montagna*, 1921, p.7 and A. Scharf, *The Merton Collection*, 1950, p.30, accepted Venturi's dating. A. Foratti, *Bartolomeo Montagna*, 1908, pp.15–16, C. J. Ffoulkes, *op. cit.*, p.248 and R. Pallucchini, *La pittura veneta alla Mostra 'Italian Art and Britain'. Appunti e proposte*, Festschrift Eberhard Haufstaengl, 1961, p.74 all date No.9375 to the early part of Montagna's career. L. Puppi, *Bartolomeo Montagna*, 1962, p.107 notes that the association of No.9375 with Montagna's Vicenza *Virgin and Child with Sts. Monica and Mary Magdalene* is relevant but that this dating could be anticipated by a few years. **4.** Pointed out by B. Berenson, *Lorenzo Lotto*, 1901, p.50. For this altarpiece, see also F. Barbieri, *I Museo Civico di Vicenza Dipinti e Sculture dal XIV al XV Secolo*, 1962, pp.164–167. **5.** A. Venturi, *op. cit.*, p.465. For this altarpiece, see also L. Puppi, *op. cit.*, pp.108–09. **6.** T. Borenius, *op. cit.*, p.22. For this painting, see also C. Lloyd, *A Catalogue of the Earlier Italian Paintings in the Ashmolean Museum*, 1977, pp.120–22. **7.** See L. Puppi, *op. cit.*, pp.130–31, 137 and 127 and figs.15, 27 and 24. **8.** See 1891 Royal Academy exhibition catalogue, cat. no.156, T. Borenius, *op. cit.*, p.23, R. De Suarez, *op. cit.*, p.7 and L. Puppi, *op. cit.*, p.107. B. Berenson, *Venetian Painters of the Renaissance*, 1894, p.107 and *Italian Pictures of the Renaissance Venetian School*, Vol.1, 1957, p.115, preferred St. Roch, although the figure does not have the pilgrim's hat and staff customary in depictions of this saint. **9.** G. F. Hill, *Francesco Gonzaga and Bartolommeo Montagna*, The Burlington Magazine, Vol.60, 1932, p.368. This identification depends upon the similarity between the physiognomy of the bearded figure in No.9375 and that of the donor portrait of Francesco in Mantegna's *Madonna della Vittoria* in the Louvre, painted to commemorate the Battle of Fornovo of 1495. **10.** Hill's identification was accepted by A. Scharf, *op. cit.* and E. K. Waterhouse in Royal Academy, *Italian Art and Britain*, p.126, No.340. This identification presupposes that the halo above the bearded figure is a later addition. In the *Madonna della Vittoria*, as in the medals of Francesco cited by G. F. Hill, *op. cit.*, Francesco is depicted wearing plate armour, without a cloak. **11.** See F. Heinemann, *Giovanni Bellini e i Belliniani*, 1959, Vol.1, pp.14–15, No.470 and pp.28–29, No.111 and Vol.2, pls.76 and 238. **12.** See F. Heinemann, *op. cit.*, Vol.1, pp.183–184 and Vol.2, pl.667. **13.** J. P. Richter, *op. cit.* The selection of pictures for Mond was left to Richter; J. P. Richter, *op. cit.*, p.39. **14.** 1891 Royal Academy exhibition catalogue, cat. no.156, as lent by her. **15.** Both Richter and Henriette Hertz were closely involved with Mond's collection; for the relationship between Hertz and Mond see particularly Robert Mond's preface to J. P. Richter, *La Collezione Hertz e gli Affreschi di Giulio Romano nel Palazzo Zuccari*, 1928, who states that 'he (Ludwig Mond) also acquired most of the pictures comprised in the Hertz Collection'.

POUSSIN, Nicolas, 1593/4–1665

10350 Landscape with the Ashes of Phocion

Canvas, 116.5×178.5

Phocion, (B.C.402–317) was an Athenian general and statesman noted for his valour as a soldier and caution as a politician; he belonged to the oligarchical party in Athens and favoured good relations with the Macedonian conquerors, Philip, Alexander and Antipater; after the death of Antipater the democratic party briefly gained control at Athens in alliance with one of the Macedonian generals, Polyperchon; these generals were then fighting among themselves for control of the Empire; with Polyperchon's connivance Phocion was executed by order of the Athenian assembly; since the charge against him had been treason his body was ordered out of Attica and taken to the boundary between Attica

and Megara where it was burnt; a woman of Megara (or Phocion's widow) first performed the appropriate rites and then collected and hid the bones; eventually when the political climate at Athens changed again the ashes were interred at a public funeral there.[1] No.10350 shows the collection of the ashes; its pendant is the *Landscape with the Body of Phocion carried out of Athens* (now on loan from the Earl of Plymouth to the National Museum of Wales, Cardiff). Presumably the city in the background of No.10350 is intended to be Megara as it has the two rocks characteristic of ancient Megara although Phocion's body would presumably have been burnt – and its ashes collected – on the boundaries between Athenian and Megarian territory well away from the city of Megara itself. Athens and Megara were at that time virtually at war as Megara was held by Cassander. The central temple in No.10350 is in fact taken from a reconstruction by Palladio of a temple at Trevi.[2]

In 1944 Blunt related the subject of No.10350 to the anti-democratic views of the 17th Century French bourgeois patrons who commissioned many of Poussin's paintings in his later years and he drew an analogy between the conflicts of 4th Century (B.C.) Athens and of 17th Century France[3]; in 1966 he more particularly emphasized the Stoic character of Phocion – using the term Stoic loosely to refer to Phocion's austerity, rectitude and contempt for public opinion – and argued that these qualities could be found in Poussin's own style, subjects and character, and in that of his circle, implying therefore a precise didactic purpose for No.10350.[4] Verdi in 1982 endorsed both of Blunt's interpretations of the subject of No.10350 and further argued that the Phocion paintings were one example of Poussin's interest in the impact of Fortune on men's lives – an interest particularly noticeable in the landscapes of 1648–1651.[5]

The two Phocion paintings, No.10350, and the *Landscape with the Body of Phocion carried out of Athens,* both dated by Felibien to 1648,[6] are among the first of a group of landscapes of 1648–1651 conceived in a new heroic or ideal manner; in No.10350, for example, the solemn grandeur of the subject is reflected in the rigid structure, the geometrical organisation, the ponderous solidity and the perfect calm of the landscape and townscape.[7] It was presumably to the insistent and obtrusive order and rational articulation of the composition that Bernini referred in 1665 when he remarked of No.10350: 'il signore Poussin e un pittore che lavora di là' while indicating his forehead.[8]

Two pentimenti can be detected in No.10350; there are clouds visible under the rocky crags in the centre and the higher of the two distant buildings just to the right of the central hill extends to the left behind the hill.

Engraved: Etienne Baudet (1684)[9]; Simon de la Vallée.[10]

Prov: Painted for Cerisier[11] in 1648; still in his possession in 1665.[12] Acquired[13] by the 12th Earl of Derby between 1776 and 1782; purchased in 1983 by the Walker Art Gallery with the aid of contributions from the National Heritage Memorial Fund, the Victoria and Albert Museum Grant Fund, the National Art-Collections Fund and other benefactors.

Exh: Manchester Art Treasures 1857 (607); Paris Louvre, *Nicolas Poussin,* 1960 (81).

Ref: **1.** Poussin could barely read Latin (see H. Bardin, *Poussin et la Litterature Latine* in

Colloque Nicolas Poussin, Actes, ed. Chastel 1960, Vol.1, pp.124ff) and presumably could not read Greek at all, so he must have relied on French or Italian translations for the Phocion story; Plutarch's account of Phocion was the most famous and Jacques Amyot's translation of it into French the best and most widely available in the 17th Century (see R. H. Barrow, *Plutarch and his Times,* 1967, pp.162ff for the translations). Amyot (*Les Vies des Hommes illustres Grecs et Romains,* 1619, p.497) describes the events represented in No.10350 thus (spelling modernized): 'Mais un pauvre homme . . . prit le corps et l'emporta par delà la ville d'Eleusine, et prenant du feu sur la terre des Megariens le brula: et y eut une dame Megarique, laquelle se rencontrant de cas d'aventure à ces funerailles avec les servantes, releva un peu la terra à l'endroit où le corps avait été ars [burnt] et brûlé et en fit comme un tombeau vide, sur lequel elle répandit les effusions qu'on a accoutumé de repandre aux trépassés, mais recueillant les os, elle les porta dedans son giron la nuit en sa maison'. In fact, Plutarch's text, if correctly read, states that Phocion's widow, not the woman of Megara, collected the ashes but it seems that this improved reading was not available until the 19th Century; George Holt, *letter,* 7 April 1983, first pointed this out and Dr. J. Pinsent, *letter,* 29 October 1983, gave further help. **2.** A. Blunt, *Nicolas Poussin,* 1967, text Vol., p.236. A. Palladio, *Quattro Libri dell'Architettura,* book IV, Chapter 25. For the topography of Megara, see R. P. Legon, *Megara,* 1981, pp.21ff and Pausanias, *Description of Greece,* ed. Loeb, 1931, Vol.1, pp.211ff. **3.** A. Blunt, *The Heroic and Ideal Landscape in the Work of Nicolas Poussin,* Journal of the Warburg and Courtauld Institutes, Vol.7, 1944, pp.158ff. **4.** Blunt, 1967, *op. cit.,* pp.165ff. **5.** R. Verdi, *Poussin and the Tricks of Fortune,* Burlington Magazine, 1982, Vol.124, pp.682ff. **6.** Felibien's *Life of Poussin,* ed. Pace, 1981, p.124. Only G. Wildenstein, *Les graveurs de Poussin au XVIIe Siècle,* 1957, p.247, seems to have doubted that No.10350 is the original painting by Poussin listed by Felibien but see M. Davies and A. Blunt, *Some Corrections and Additions to M. Wildenstein's Graveurs de Poussin,* Gazette des Beaux Arts, 1962, p.215, for the misunderstanding on which Wildenstein's opinion was based. Most recently J. Thuillier in *Tout l'oeuvre peint de Poussin,* 1974, No.156, has discussed the matter in a somewhat guarded manner, but conceded that No.10350 is of very high quality and likely to be the original painting. **7.** This analysis follows Blunt, 1944, *op. cit.,* and Blunt, 1967, *op. cit.,* pp.294ff. The reasons for Poussin's new interest in landscape in 1648 are discussed by W. Friedlander, *Poussin,* 1966, pp.77ff. Kurt Badt, *Die Kunst des Nicolas Poussin,* 1969, Vol.1, pp.602–603, analyses Poussin's classical attitude to death in No.10350. F. G. Stephens provided a fine analysis of No.10350 in the *Athenaeum,* 1881, p.441, especially emphasizing the brooding, ominous quality of the landscape while William Hazlitt's famous article on Poussin's *Orion (Criticism on Art,* second series, 1844, pp.190ff) may have been partly inspired by No.10350 – which he is likely to have seen as he had Liverpool connections. **8.** M. de Chantelou, *Voyage du Cavalier Bernin en France* in J. Thuillier, *Pour un Corpus Pussinianum,* in *Colloque Nicolas Poussin, Actes,* ed. Chastel, 1960, Vol.2, p.127. Blunt, 1944, *op. cit.,* pp.163ff connects this rational or mathematical content in Poussin's compositions with the teaching of Descartes. **9.** G. Wildenstein, *Les Graveurs de Poussin au XVIIe Siècle,* 1957, No.184, p.247. **10.** Wildenstein, *op. cit.* **11.** Cerisier was a Lyons silk merchant; he was in Rome in November 1647; for further details of his career see Blunt, 1944, *op. cit.,* pp.160–161. **12.** Chantelou, *op. cit.,* **13.** Versions of No.10350 and of the *Landscape with the Body of Phocion carried out of Athens* were together in the collections (successively) of Pierre de Beauchamp, Denis Moreau and Louis de Nyert, Marquis de Gambais, but the inventory of Louis de Nyert taken at his death in 1736 revealed that his version of No.10350 was a copy (Blunt, 1967, *op. cit.,* catalogue Vol. pp.124–125, Nos.173–174). Copies after No.10350 are listed by Blunt, *op. cit.,* but it should be noted that the one formerly owned by Lord St. Oswald was destroyed by fire in about 1980 while the one owned by the Hon. Mrs. Marten was sold at Christie's in about 1963. Henry Hope (1735–1811) owned copies after No.10350 and after the *Landscape with the Body of Phocion carried out of Athens;* they were sold at his Sale, Christie's, 27 June 1816, lots 57 and 58 bought (respectively) Scott £52:10:0 and Hill £50:8:0 – see M. G. Buist, *At Spes non fracta: Hope and Co. 1770–1815,* 1974, pp.488–489; these copies are not listed by Blunt, *op. cit.;* they are unlikely to be the versions in the Dickenson Sale as Hope imported his copies into England from the Netherlands in 1794. G. Scharf, *Catalogue of the Collection of Pictures at Knowsley Hall,* 1875, No.77, p.40, records the purchase of No.10350 by the 12th Earl of Derby who succeeded to the title in 1776; No.10350 is first recorded in his collection in the *Catalogue of the Paintings at Knowsley taken in 1782,* Prescot, p.5; Scharf, *op. cit.,* states that No.10350 came from the French Royal Collections but this seems unlikely (Jacques Foucart, *letter,* 2 November 1982,

quoting F. Engerand *Inventaire des tableaux commandés et achetés par la Direction des Batiments du Roi, 1709–1792*, 1900); versions of No.10350 and of the *Landscape with the Body of Phocion carried out of Athens* were in the Samuel Dickenson Sale Christie's 11 March 1774, lots 78–79 bought Beauvais. Maria Graham (Lady Callcott) *Memoirs of the Life of Nicholas Poussin*, 1820, p.228, describes No.10350 (or a version of it) but does not locate it at Knowsley and describes it as the *Tomb of Phocion*. Technical evidence indicates that No.10350 and the *Landscape with the Body of Phocion carried out of Athens* now owned by the Earl of Plymouth were relined in the same studio and at the same time; if indeed Louis de Nyert owned the latter but not the former, perhaps these two paintings came together again when they were imported into England in the late 18th Century.

TISSOT, James Jacques Joseph, 1836–1902

9523 Catherine Smith Gill and two of her children

Canvas, 152.5 × 101.5

Signed: *J. J. Tissot/1877*

Catherine Smith was the daughter (and only child) of Thomas Carey of Lower Lee, Woolton, Liverpool, who died in 1875; in 1868 she married Chapple Gill, later the senior partner of the Liverpool cotton brokers, R. and C. Gill[1]; their children were Thomas Carey (Gill-Carey), Margaret Helena Kate (Saville), Evelyne Carey (Chapple Gill), Robert Carey (Chapple Gill) and Viva (Chapple Gill)[2]; the child in the centre of No.9523 is Robert Carey Chapple Gill,[3] then two years old, and the girl at the right is stated to be Margaret Helena Kate (Saville) then aged six.[4] In No. 9523 the three figures are inside Lower Lee[5] which was then the home of Mrs. Catherine Carey, mother of Mrs. Catherine Smith Gill; at that time Mr. and Mrs. Chapple Gill lived at Knotty Cross, Halewood Road, Gateacre; Mrs. Catherine Smith Gill died in 1916.

It is said that the artist was invited to Liverpool to paint this portrait[6] and he spent eight weeks at Lower Lee enjoying a close relationship with Catherine Smith Gill.[7] Wentworth comments on the pale tonalities and on the generalizing large scale brushwork in No.9523.[8]

There are still in the family collection portraits of Robert Carey Chapple-Gill by J. R. Herbert dated 1880 and by J. Sant (exhibited at the Liverpool Autumn Exhibition, 1881, No.142).

Prov: Robert Carey Chapple-Gill; his son, Berkeley Chapple-Gill; Berkeley's wife, Mrs. M. I. Chapple-Gill from whom it was purchased by the Walker Art Gallery 1979 with the aid of contributions from the Victoria and Albert Museum Grant Fund and the National Art-Collections Fund.

Ref: **1.** B. G. Orchard, *Liverpool's Legion of Honour*, 1893, p.322, with more information about him. **2.** This list is taken from Catherine Smith Gill's will (probate granted 14 February, 1917). **3.** Berkeley Chapple-Gill, *verbally*, 1979. **4.** Michael Wentworth, *J. J. J. Tissot*, 1984, p.142. **5.** Berkeley Chapple-Gill, *op. cit.;* there is an old photograph of the house, now demolished, in the Walker Art Gallery. **6.** Berkeley Chapple-Gill, *op. cit.* **7.** Wentworth, *op. cit.* **8.** Wentworth, *op. cit.*

CATALOGUE OF DRAWINGS AND WATERCOLOURS

BOLOGNESE School, early 17th century

9282 Death of Saint Joseph

Red chalk, pen and brown ink, brown wash, 22.7×17.5

Inscribed: *WE* and *Bonesi* (on reverse)

The traditional attribution of No.9282 was upheld by Nicholas Turner; Julien Stock suggested that the artist may have been a Florentine.[1] The subject of the *Death of St. Joseph* was very popular during the 17th century.[2] Both the schematic drawing and the discontinued wash shading at the top left suggest that No.9282 may be a copy.[3]

Prov: William Roscoe sold Winstanley Liverpool, 23 September 1816 (350) bt. Esdaile £1:16:0; William Esdaile sold Christie's 18 June 1840 (291) £0:2:6 (together with lots 290 and 292). I.G.A. (Old Masters) Ltd. Sold Christie's 29 November 1977 (54) bt. for Walker Art Gallery.

Ref: **1.** *Letters* from N. Turner of 5 August 1983 and P. Pouncey of 2 August 1983. **2.** For a long list of versions of this subject, see A. Pigler, *Barockthemen*, 1974, Vol.1, pp.439–45. Most of these versions include a similar range of compositional and iconographic motifs to that which appears in No.9282, including the foreshortened bed, gesticulating figure of Christ and group of angels. **3.** N. Turner was of the opinion that No.9282 could well be a copy, *letter* of 5 August 1983.

FUSELI, John Henry, 1741–1825

1540 Death of Cardinal Beaufort

Pen, ink, pencil and grey wash, 65×81.9

Signed: *Fuseli*

Inscribed: *Roma 72*

The subject is taken from Shakespeare's *Henry VI,* Part 2, Act 3, Scene 3; Cardinal Beaufort is dying in terror – partly due to his complicity in the murder of Humphrey, Duke of Gloucester; the young Henry VI in the centre raises his arm and says:
Lord Cardinal, if thou thinkst on heaven's bliss
Hold up thy hand, make signal of thy hope.
He dies and makes no sign. O God forgive him!
At the extreme left are the Earl of Salisbury and his son the Earl of Warwick, two of the future leaders of the House of York; at the extreme right is the apothecary with the poison ordered by Beaufort; kneeling in

the foreground appear a row of monks praying for Beaufort and, facing the spectator, his confessor; the two figures next to the apothecary are interpreted by Schiff as representing the spirits or demons of Beaufort's conscience.[1]

No.1540 was the first major work by Fuseli to be publicly exhibited in England and of great importance both in the development of the artist's style and in the reception of Roman neoclassicism in Britain. Antal[2] noticed in No.1540 'an agitated, jerky, slightly classicist, not quite unrealistic, style with mannerist elements carried over from the Shakespearean illustrations done in England'; Schiff[3] saw in it the even lighting, the subdued shadows, the parallel arrangement of figures and of gestures, the careful, flat composition and controlled pen strokes of Fuseli's 'official' or classicizing style in the early 1770's; both authors point to the more baroque qualities of the related preparatory drawing now in the Henry E. Huntington Library and Art Gallery, San Marino.[4]

Clearly No.1540 is a transitional drawing between baroque and neoclassicism and there are mannerist borrowings, but for the compiler the importance of No.1540, particularly as an exhibited, finished drawing, lies in those elements which anticipate the style of the Romney – Blake – Fuseli – Flaxman circle of ten or twenty years later: that is the expressionist vigour of the abstract, generalized style, the use of repeated forms, of staring faces and of the supernatural generally.[5]

No.1540 is the first illustration of this subject outside book illustration,[6] the scene was popular with contemporary English critics especially for its ingredients of fear and pity in the contrasting attitudes of the King and of the Cardinal.[7] These qualities are emphasized by Fuseli's adoption of a generalized, indeterminate setting and costume rather than the more detailed descriptive reportage of his earlier Shakespearean drawings.[8] *Henry VI, Part 2,* was not performed at all in London between 1751 and 1800[9] – Fuseli first arrived in London in 1764 so he certainly did not see the play performed there before 1772.

The sources of No.1540 have been extensively discussed. Nicolas Poussin's *Death of Germanicus* (Minneapolis Institute of Arts),[10] Benjamin West's *Departure of Regulus* (Royal Collections),[11] Raphael's *Death of Ananias* (Royal Collections) and *Expulsion of Heliodorus* (Vatican),[12] Giovanni da Bologna's *Hercules and the Centaur* (Loggia dei Lanzi, Florence)[13] and Gavin Hamilton's *Andromache bewailing the Death of Hector* (engraved Cunego 1764)[14] have all been suggested; however, the connection with Gavin Hamilton seems perhaps most significant – not only with his *Andromache bewailing the Death of Hector* but also with his *Achilles bewailing the Death of Patroclus* (National Gallery of Scotland, Edinburgh). The influence of No.1540 on Joshua Reynolds's *Death of Cardinal Beaufort* of 1789 (Petworth, Sussex)[15] seems undeniable; Fuseli returned to the same subject for a painting in 1808[16] and for two book illustrations in 1803[17] but all lack the intensity of No.1540. The two book illustrations seem to depend on Reynolds's version.

Prov: Acquired by the Liverpool Royal Institution between 1836 and 1843[18]; deposited at the Walker Art Gallery 1893; presented to the Walker Art Gallery 1948.

Exh: Royal Academy, 1774, No.90; Liverpool, Society for Promoting Painting and Design in Liverpool, 1787, No.26; Liverpool Academy, 1814, No.104; Manchester, *Art Treasures,* 1857, No.256.

Ref: **1.** G. Schiff, *Johann Heinrich Fussli,* 1973, Vol.1, p.105. Reynolds introduced a similar figure into his 1789 *Death of Cardinal Beaufort* (Petworth, Sussex) and this provoked considerable controversy (A. S. Roe, *The Demon behind the Pillow,* Burlington Magazine, 1971, Vol.113, pp.460ff.) N. Powell, *Fuseli: The Nightmare,* 1973, p.31, interprets the figure of the Confessor in particular as evidence that No.1540 is anti-Catholic; this seems very doubtful. **2.** F. Antal, *Fuseli Studies,* 1956, pp.29ff. **3.** Schiff, *op. cit.,* pp.87, 98, 105, 449. The analysis of Fuseli's style in the 1770's provided by D. Irwin, *English Neoclassical Art,* 1966, pp.44ff. follows similar lines. **4.** Schiff, *op. cit.,* No.438, p.449. Schiff wrongly locates this drawing in the Paul Mellon Collection. Antal, *op. cit.,* p.29, refers to it as another version of No.1540 and probably earlier. There is a tracing from the Huntington drawing in Fuseli's *Roman Album* now in the British Museum (Schiff, *op. cit.,* No.439, p.449). **5.** See particularly Powell, *op. cit.,* p.31. **6.** Schiff, *op. cit.,* p.105. **7.** T. S. R. Boase, *Illustrations of Shakespeare's Plays in the 17th and 18th Centuries,* Journal of the Warburg and Courtauld Institutes, 1947, Vol.10, p.103. Schiff, *op. cit.,* p.105. Powell, *op. cit.,* p.28. **8.** W. M. Merchant, *Shakespeare and the Artist,* 1959, p.78, and Antal, *op. cit.,* p.34. **9.** C. B. Hogan, *Shakespeare in the Theatre,* 1957, Vol.2. **10.** This source is favoured by most commentators except Schiff, *op. cit.,* p.449, and P. Tomory, *The Life and Art of Henry Fuseli,* 1972, p.77. **11.** Schiff, *op. cit.,* p.87, compares in particular the kneeling monks in No.1540 with the kneeling figures on the left of West's painting. **12.** Tomory, *op. cit.,* p.77. **13.** Tomory, *op. cit.,* p.78. **14.** Haus der Kunst, Munich, *Zwei Jahrhunderte Englische Malerei,* 1980, p.273, No.147. **15.** For Reynolds's painting see particularly Boase, *op. cit.* and W. H. Friedman, *Boydell's Shakespeare Gallery,* 1976, pp.118ff. where comments by Fuseli on it and comparisons with Fuseli's work are quoted. **16.** Schiff, *op. cit.,* No.1204, p.563 and No.1787, p.637; the painting was last recorded at the Sabin Galleries, London. **17.** Schiff, *op. cit.,* No.1260, p.570 (engraved by W. Bromley for R. Bowyer's *Historic Gallery*) and Schiff, *op. cit.,* No.1282, pp.572–3 (engraved by R. H. Cromek for Chalmers's *Shakespeare*). The small sketch in chiaroscuro *Death of Cardinal Beaufort,* 30×25 ins., lot 10 in the artist's sale of 28 May 1827, and lot 43 in the Thomas Lawrence Sale of 15 May 1830, may have been related to one of these book illustrations (see Hugh Macandrew, *Henry Fuseli and William Roscoe,* Liverpool Bulletin, Vol.8, 1959–1960, p.29). Fuseli was working on 'the Cardinal' around 1784, possibly yet another painting of the Death of Cardinal Beaufort, see the *Collected English Letters of Henry Fuseli,* ed. Weinglass, 1982, p.25. **18.** In a letter to William Roscoe of Liverpool of 1 August 1787 Fuseli asked 'Pray did you buy the drawing of Cardinal Beaufort'; this indicates at least that No.1540 remained with the artist until then; Roscoe may have bought it as the drawing was exhibited in Liverpool in 1787 and 1814 and was presented to the Liverpool Royal Institution between 1836 and 1843; for further details see Macandrew, *op. cit.,* p.27. It is possible that No.1540 was owned by the Reverend William Shepherd of Liverpool; in a letter to Roscoe of 9 December 1810/5 January 1811, Fuseli wrote: 'I would rather decline sending you a sketch, as they always raise expectations which no Picture can answer – the firstlings of my hand shall be on the canvas – as in the Cardinal, which Shepherd has'; Macandrew, *op. cit.,* p.30, interprets this to mean that Shepherd had an oil version of the *Death of Cardinal Beaufort* but it could mean that he had a drawing or sketch. See Weinglass, *op. cit.,* pp.37–38, 380–81 for the full text of Fuseli's letters to Roscoe, summarised by Macandrew; for Roscoe's final judgment on his works by Fuseli see above p.7, *Death of Oedipus,* footnote 9.

FUSELI, John Henry, after

8829 Study of Naked Athletes, one seen from behind

Pen and brown ink, 34.6×21.9

Inscribed: *Fuseli*

A copy of a drawing in the collection of Mr. and Mrs. J. W. Alsdorf, Winnetka, Illinois.[1]

Prov: William Roscoe who presented it to Charles M. Seddon in June 1828.[2] Joshua Fisher[3]; his son G. Birkett Fisher, sold Christie's 5 November 1974, lot 110 bought in; purchased 1974 by the Walker Art Gallery.

Ref: **1.** G. Schiff, *Johann Heinrich Fussli,* 1973, Nos.1476 and 1476a. **2.** Inscription on mount. **3.** Inscription on backboard; Joshua Fisher (1859–1943) and G. Birkett Fisher were both Merseyside artists.

GOTLIB, Henryk, 1890–1966

9274 Couples in Love in a Park

Pencil and watercolour, 17.2×21.3

9275 A Scene in a Park

Pen on graph paper, 14.2×8.9

9276 Woman Sitting in an Armchair

Pencil, 27×21

9277 Portrait of a Woman with Hands Clasped

Pencil, 27×19.5

Inscribed: (lower right in pencil) *Niedziela ranem na Bysztrem* (presumably artist's autograph), (verso) *123* (Warsaw inventory number)

9278 Portrait of a Woman

Pencil, 15.4×10.3

Inscribed: (verso) *298* (Warsaw inventory number)

9279 A Kneeling Figure with an Umbrella

Charcoal, 18.5×13.2

Inscribed: (verso) *125* (Warsaw inventory number)

9280 Woman Reading a Book

Pencil, 28.8×19.3

Inscribed: (verso) *94* (Warsaw inventory number)

In the ms. catalogue compiled by the Museum Narodowe, Warsaw, Nos.9274–9280 have the catalogue numbers 30, 45, 70, 123, 298, 125 and 94 and all are dated 'pre-1934'.[1] No.9277 and, possibly, No.9280 are portraits of Gotlib's first wife, Louta Nunberg (b.1893), a pianist who

lived in Paris for some years.[2] No.9274 is probably related to Gotlib's series of six lithographs, titled *L'Amour dans la Rue,* published at Paris in 1924 in an edition of 25.[3] No.9275 is upon a page torn out of a notebook; the paper has been folded horizontally 3.2 cm. above the lower edge. No.9276 is upon an unused sheet of letter headed note-paper of the Paris agency of the Warsaw illustrated weekly *Ilustracja;* the paper has been folded vertically parallel to the right edge and horizontally just above the lower edge to form an image area measuring 23.4×19.4 cm.[4] The apparently autograph inscription upon No.9277 may be translated: *Sunday morning on Bystre;* i.e. presumably Bystrá, a mountain on the Czech–Polish border, in the vicinity of Zakopane, and approximately 100 km. from Krakow.[5] No.9278 is upon the verso of a bill, made out to Mr. Gotlib at Krakow on 4 September, 1929; the paper has been folded diagonally across the centreline, creating an accidental(?) counterproof at the bottom of the page.

Prof: Left by the artist in his Krakow studio in 1931 or 1932, found by Hanna Cybis and given in 1974 to the artist's widow Mrs. Janet Gotlib, from whom purchased as a lot, together with No.9273, January.1978.[6]

Ref: **1.** Janet Gotlib,*letter* of 30 November 1977. **2.** See Janet Gotlib,*letters,* 29 August and 15 September 1983. Little is known about Louta Nunberg. See Prof. Juliusz Bursze,*letter,* 22 September 1983. **3.** See Janet Gotlib,*letter,* 29 August 1983. Set number 18 of this edition is in the collection of Mrs. Gotlib. **4.** The name and address, as given on the letterhead, is *Illustracja/Hebdomadaire illustré/Varsovie/Agence pour la France/26 bis Rue Nansouty Paris 14e.* Gotlib lived mainly in France during 1923–30, where he is known to have been an art correspondent for the Warsaw *Times.* See *Homage to Henryk Gotlib,* Leicestershire Museums and Art Galleries 1983, p.15. **5.** The compilers are grateful to Leon Vilaincour for this translation. **6.** Nos.9274–9280 are part of an archive of 600 drawings. In 1975 Janet Gotlib presented 140 of these to the Muzeum Narodowe, Warsaw, and brought the remainder to Britain. See Janet Gotlib, *Henryk Gotlib – His Early Works,* Orbit, December, 1975, and *Henryk Gotlib,* Muzeum Narodowe, Warsaw 1980, pp.74–76 and pl.27–33.

GRUBER, Karl Franz, 1803–1845

9785 Botanical Studies

Gouache, 45×32.5

Signed: *Franz X Gruber/kk Prof.* superimposed upon the partly-erased signature: *Carl Gruber ft* (? indistinct)

Inscribed: *1. Epipactis rubra 20–2*
 2. Lychnis Floscuculi 10–5
 3. Linum tenuifolium 5–1
 4. Galia Helvetia
 5. Aconitum Jacquinianum 12–3

Four different plants are illustrated; from left to right: *Helleborine orchid,* (which grows in the wild in Austria), *Ragged Robin (Lychnis flos-cuculi),* two sprigs of *Narrow-leaved Flax (Linum tenuifolium)* and *Yellow Monkshood (Aconitum jacquinii,* rather than *Aconitum Jacquinianum).* The Latin name *Epipactis rubra,* given in the legend to the *Helleborine orchid,* is not a recognised species. The *Yellow Monkshood* is

depicted with greenish white petals, rather than the yellow which one might expect. The *Galia Helvetica* mentioned in the legend, which should properly read *Galium helveticum* and is a species of *Bedstraw,* is not illustrated.[1]

The Viennese Karl Franz Gruber was the brother and student of Prof. Franz Xaver Gruber (1801–1862).[2] Both were flower painters. The partly-erased signature *Carl Gruber* is in the same hand as the signatures on Nos.9787 and 9788. This signature is apparently in the same hand as that on a study of wild flowers, signed *Carl Gruber,* in the Historisches Museum der Stadt Wien.[3] The latter is stylistically comparable with Nos.9785–9788. The second signature on No.9785, *Franz X. Gruber,* is in similar ink to the legend, with which it may be contemporary. As the legend mis-spells two botanical names and includes one species which is not illustrated, it seems likely that it was added by someone with little knowledge of botany. This legend is in the same hand as those on Nos.9787 and 9788.

Prov: The Earls of Sefton; bequeathed by the Countess of Sefton 1980.

Ref: **1.** I am grateful to Dr. J. Edmondson for the above identification of the botanical studies illustrated in No.9785, *letter, 28 October 1983.* **2.** See U. Thieme and F. Becker, *Allgemeines Lexikon der Bildenden Künstler,* Vol.15, 1922, pp.121 and 119–20. **3.** HM Inv. Nr.116 822/1. See exhibition catalogue *Blumen und Gärten,* Historisches Museum der Stadt Wien, 25 April–16 June 1974, cat. no.24 and pl.5. I am indebted to Dr. Hans-Walter Lack for this reference.

9786 Martagon Lily (Lilium martagon)

Gouache, 45×32.5

No.9786 has the same provenance, and is apparently by the same hand as Nos.9785, 9787 and 9788.

Prov: See No.9785, above.

Ref: **1.** I am grateful to Dr. J. Edmondson for the above identification of the subject of No.9786, *letter,* 28 October 1983.

9787 Botanical Studies

Gouache, 45×32.5

Signed: *Carl Gruber*

Inscribed: *1. Calendula officinalis iq Nec*
2. Thalia dealbata
3. Comelina coelestis
4. Solanum dulcamara

Four different plants are illustrated; from left to right: *Pot-Marigold (Calendula officinalis), Thalia dealbata* (a North American member of the banana family, cultivated in Europe in hot-houses), *Commelina* (rather than *Comelina*) *coelestis* (an ornamental species with no familiar English name) and *Woody Nightshade (Solanum dulcamara)*.[1]

The signature is in the same hand as the earlier one on No.9785 and that on No.9788. The legend is in the same hand as those on Nos.9785 and 9788, which also include botanical mis-spellings.

Prov: See No.9785, p.24.

Ref: 1. I am grateful to Dr. J. Edmondson for the above identification of the botanical studies illustrated in No.9787, *letter,* 28 October 1983. For Karl Franz Gruber, see U. Thieme and F. Becker, *Allgemaines Lexikon der Bildenden Künstler,* Vol.15, 1922, p.121.

9788 Botanical Studies

Gouache, 45×32.5

Signed: *Gruber*

Inscribed: *Melittus Melissophylum 14*
Echium vulgare 5–1

The two plants illustrated are, from left to right: *Bastard Balm (Melittis melissophyllum,* rather than *Melittus Melissophylum)* and *Viper's Bugloss (Echium vulgare)*.[1]

The signature is in the same hand as the earlier one on No.9785 and that on No.9787. The legend is in the same hand as those on Nos.9785 and 9787, which also include botanical mis-spellings.

Prov: See No.9785, p.24.

Ref: 1. I am grateful to Dr. J. Edmondson for the identification of the botanical studies illustrated in No.9788, *letter,* 28 October 1983. For Karl Franz Gruber, see U. Thieme and F. Becker, *Allgemeines Lexikon der Bildenden Künstler,* Vol.15, 1922, p.121.

ITALIAN School, 18th century

9886 Study of a Fountain

Black chalk, 19.6×14.1

Inscribed: (recto) *75* and (verso) *14 Xembre 1837* and an indecipherable collector's mark

No.9886 was attributed to Paolo Gerolamo Piola by Mary Newcombe, who was of the opinion that the grotto imagery was comparable with that of Domenico Parodi.[1] Hugh Macandrew considered that No.9886 may be

Genoese.[2] An alternative attribution, to the French school, has also been suggested.[3] At present, it does not seem possible to advance a definitive attribution.

Prov: Unidentified Italian(?) private collection[4]; R. W. Warrington[5]; inherited by his sister, Miss Porter, by whom presented to Liverpool City Museum, 1953; transferred from Merseyside County Museums as part of a lot comprising Nos.9880–10122 November 1981.

Ref: 1. *Letter*, 5 December 1983. Compare, for example, with Parodi's drawings for an altarpiece dedicated to St. Francis Xavier and of *A Man Worshipping a Female Saint in a Grotto*, both at the Victoria and Albert Museum (8653.1 and 8492.6). See P. Ward-Jackson, *Italian Drawings*, vol.2, *17th–18th century*, 1980, cat. nos.1061 and 1074. 2. *Letter*, 21 November 1983. 3. By Giulia Bartrum, *letter*, 7 September 1983. 4. On the basis of the inscriptions and collector's mark on the verso of Nos.9881–9886. 5. For the artist and stained glass designer Richard William Warrington (1868–1953), see Walker Art Gallery, *Merseyside Painters, People and Places*, 1978, p.214. Nos.9880–10122 comprised part of Warrington's estate.

MARTINO, Eduardo de, 1838–1912

9342 River Scene with Boat

Watercolour, 6.4×6.4

Signed: *E. Di Martino*(?)

No.9342 is one of thirty-two small watercolours all occupying the white squares of a chessboard; the watercolours were commissioned by Philip Henry Rathbone (1828–1895) for whom the chessboard was made.[1] The earliest dated watercolours were painted in 1875 and the latest dated watercolour was painted in 1888. See also pp.30–31.

Prov: Philip H. Rathbone; by descent to Miss Diana M. Moore who presented it to the Walker Art Gallery 1978.

Ref: 1. Major W. A. M. Moore, note on the origin of the chessboard of 11 September 1953; the artists of the watercolours were usually friends or guests of Rathbone; for Rathbone see Edward Morris, *Philip Henry Rathbone and the purchase of contemporary foreign paintings for the Walker Art Gallery, Liverpool, 1871–1914*, Annual Report and Bulletin of the Walker Art Gallery, 1975–1976, Vol.6, pp.59ff.

PIOLA, Paolo Gerolamo, 1666–1724

9880 Study of a man kneeling by a jar

Ink and wash, heightened with white gouache (oxidised in places), 20.5×17.7

Mary Newcome pointed out that the composition is identical with that of part of the bottom left corner of a drawing in New York of *Christ in the House of Martha and Mary* attributed to P. G. Piola.[1] The attribution to Piola was accepted by Christel Thiem and Hugh Macandrew.[2] It has been suggested that the New York drawing is a design for a fresco and may be related to Piola's decorations in the church of Santa Marta in Genoa.[3] If No.9880 is a fragment of the working cartoon, it would appear that the design was intended for a painting measuring no more than c. 80×90 cm.

Prov: R. W. Warrington[4]; inherited by his sister, Miss Porter, by whom presented to the Liverpool City Museum, 1953; transferred from Merseyside County Museums as part of a lot comprising Nos.9880–10122 November 1981.

Ref: **1.** *Letter,* 5 December 1983. Metropolitan Museum of Art, 1983, 57. This drawing, which measures 40.7×52.7, is at a considerably smaller scale than No.9880. **2.** *Letters,* 30 November 1983 and 21 November 1983. **3.** See *Notable Acquisitions 1982–1983 The Metropolitan Museum of Art,* 1983, pp.46–47. The kneeling figure which appears both in No.9880 and the New York drawing is not present in this fresco. Jacob Bean, *letter,* 10 February 1984. **4.** For the artist and stained glass designer Richard William Warrington (1868–1953), see Walker Art Gallery, *Merseyside Painters, People and Places,* 1978, p.214. Nos.9880–10122 comprised part of Warrington's estate.

9882 Vigilance

Ink and wash, 21×24.8

Inscribed: (recto). . . (obliterated) *73 Vigilanza* and (verso) *Paolo Gerol^mo Piola Inv Del^n 27 Novbre 1830* and an indecipherable collector's mark

The verso bears an ink drawing of a group of *putti*. The sketch on the recto may be a study for a sculptural entablature above an altarpiece.[1] The attributes and the pose of the allegorical figure in No.9882 are reminiscent of those of a statue of *Vigilance* in the right transept of St. Peter's in the Vatican.[2] However, the bird which appears in this and other representations of the allegorical figure, derived from Cesare Ripa's *Iconology* (first published 1593; numerous subsequent editions), is not visible in No.9882.[3] Hugh Macandrew was of the opinion that No.9882 is Genoese and acceptable as an autograph work by Paolo Gerolamo Piola, while Christel Thieme and Mary Newcome attributed it to the workshop of Piola.[4]

Prov: See No.9886, p.25.

Ref: **1.** Such as the female *Virtues* carved by Pellegro Olivari above P. G. Piola's altarpiece in the Torre Chapel, N.S. della Consolazione, Genoa. See M. Newcome, *letter,* 5 December 1983 and *Genoese Settecento Decoration by the Casa Piola,* The Burlington Magazine, August 1978, p.534 and pl.53. **2.** See E. Mâle, *L'Art Religieux de la fin du XVIe Siècle du XVIIe Siècle et du XVIIIe Siècle,* 1951, pp.394–395 and fig.228. **3.** See E. Mâle, *op. cit.,* p.387ff. **4.** *Letters,* 21 November 1983, 30 November 1983 and 5 December 1983.

9884 Two studies of Lot and his Daughters

Black chalk, 20.5×17.7

Inscribed: (verso) *5 Novbre 1829 la Ger^mo Piola* and an indecipherable collector's mark.

For a comparable sheet of studies in a similar technique, see the *Two studies of Holy Women buying Ointments,* attributed to Piola, in the Janos Scholz collection, New York.[1] For the handling of the faces of the figures in No.9884, see the *Beheading of St. John the Baptist,* also attributed to Piola and in the Janos Scholz collection.[2] No.9884 was accepted as autograph by Christel Thieme, Mary Newcome and Hugh Macandrew.[3]

Prov: See No.9886, p.26.

Ref: 1. See M. Newcome, *Genoese Baroque Drawings,* University Art Gallery, State University of New York at Binghampton, 1–31 October 1972, p.48 and pl.124. **2.** See M. Newcome, *op. cit.,* p.48 and pl.127. The compilers are indebted to Giulia Bartrum for the above references, *letter,* 7 September 1983. **3.** *Letters,* 30 November 1983, 5 December 1983 and 21 November 1983.

9885 Atalanta and Meleager

Black chalk, 16×13.2

Inscribed: (verso) *14 Xembre 1839* [pl] *Ger*[m] *Piola Meleager e Atlanta* and an indecipherable collector's mark

For a closely comparable study in a similar technique which includes a female figure with a head like that of Atalanta and with squarish toes, like those of Meleager, see Piola's drawing of *Judith and Holofernes* in the Fondazione Cini in Venice.[1] No.9885 was accepted as autograph by Christel Thieme, Mary Newcome and Hugh Macandrew.[2]

Prov: See No.9886, p.26.

Ref: 1. Inv. No.30, 988; Gernsheim No.6889. The compilers are indebted to Giulia Bartrum for this reference, *letter,* 7 September 1983. **2.** *Letters,* 30 November 1983, 5 December 1983 and 21 November 1983.

9881 Apollo Flaying Marsyas

Black and white chalks on grey paper, 26.2×20

Inscribed: (on mount) *paulo Gerolamo Piola* and *103* (verso) *9 Gennaio 1830* and an indecipherable collector's mark

9883 The Prodigal Son

Black and white chalks and wash, 22×31.5

Inscribed: (verso) *9 Xembre 1828 di P Gio*[m] *Piola* and an indecipherable collector's mark

For comparable drawings attributed to Piola, see the *Susanna and the Elders* and the *Calling of St. Peter,* both in the Staatsgalerie, Stuttgart.[1] However, the quality of No.9881 and, particularly, No.9883 is lower than that of Nos.9884 and 9885 and the Stuttgart drawings, which are apparently autograph. Hugh Macandrew was of the opinion that Nos.9881 and 9883 are autograph.[2] Christel Thieme accepted No.9883 as autograph and thought that No.9881 could be a copy after Piola.[3] Mary Newcome accepted both as autograph.[4]

Prov: See No.9886, p.26.

Ref: 1. Graphische Sammlung 6332 and 6333. See M. Newcome, *Genoese Baroque Drawings,* University Art Gallery, State University of New York at Binghampton, 1–31 October 1972, p.48 and pls. 125 and 126. The compilers are indebted to Giulia Bartrum for the above references, *letter,* 7 September 1983. **2.** *Letter,* 21 November 1983. **3.** *Letter,* 30 November 1983. **4.** *Letter,* 5 December 1983.

SALOMÉ, Antoine de or SOLOMÉ, Anton, active 1835–1872

3224 George Melly

Pastel, 69.8×52.7

Signed: *A de Salomé 1872*

George Melly (1830–1894) was a member of a well-known Liverpool merchant family; he was Liberal M.P. for Stoke on Trent from 1868 to 1874 and was noted for his philanthropic work in Liverpool.[1]

Prov: Presented by the descendants of George Melly 1944.

Ref: 1. For further details see W. H. Rawdon Smith, *The George Mellys*, 1962. The MSS Correspondence of George Melly (Liverpool City Libraries) has not been examined.

10255 Cecil Emily, Countess of Sefton

Pastel, 68.5×52

Signed: *A. de Salome/1870*

The sitter was the wife of the fourth Earl of Sefton; she died in 1899.

Prov: The Earls of Sefton; presented to the Walker Art Gallery by H.M. Government 1982.

SALOMÉ, Antoine de or SOLOMÉ, Anton, active 1835–1872, after

8642 Cecil Emily, Countess of Sefton

Pastel, 63.4×49.9

No.8642 is a copy after No.10255 (see above).

Prov: The Earls of Sefton; purchased from the executors of the seventh Earl of Sefton 1974.

SIGNORELLI, Luca, 1441–1523

9833 Study of a Young Man

Black chalk, heightened with white gouache (oxidised in places), pounced and squared up, 41.0×21.5

Inscribed: *Luca Signorelli da Cortona*

Originally sketched quite lightly, the main contours were subsequently strengthened and the shading and highlights added. Some faint modifica-

tions to the original figure have also been made. The position of the young man's left hand was adjusted, fuller drapery superimposed on his upper left sleeve and the skirts of a long tunic descending from his waist to just above his knees were also added. Signorelli's only comparable life drawing of a young man in contemporary dress is a *Study of a Youth* in the Uffizi.[1] Both drawings probably date from *c.* 1499–1505, when Signorelli was engaged upon his fresco cycle at Orvieto cathedral, in which several figures in analogous costume appear.[2] As No.9833 is both pounced and squared up it may have been employed on more than one occasion although the design does not reappear in any of Signorelli's known paintings.[3] The pose of the figure, with one arm raised and one hand on hip, is similar to those of a number of soldiers beating Christ which appear in *Flagellation* scenes by the artist.[4] It therefore seems likely that the study was originally made for a representation of this theme.

Prov: Sir Thomas Lawrence[5]; probably S. Woodburn and perhaps identical with part of lot 848, Woodburn sale Christie's, 4–7 June 1860[6]; bought Baron Marochetti £5:0:0[7]; purchased in France by F. A. Drey, 1938–9; on approval[8] Lt. Col. N. R. Colville, 1939; Sir Thomas Merton 1950; accepted by H.M. Government from the executors of Sir Thomas and Lady Merton in lieu of capital transfer tax 1980[9]; allocated to the Walker Art Gallery by H.M. Government 1981.

Exh: London, Royal Academy, *Drawings by Old Masters*, 1953, cat. no.28; Nottingham, University Art Gallery and London, Victoria and Albert Museum, *Drawing in the Italian Renaissance Workshop*, 1983, cat. no.13.

Ref: **1.** Gabinetto Disegni e Stampe (n.50 E) see, *Mostra di Luca Signorelli*, Cortona and Florence 1953, no.74 and B. Berenson, *I Disegni Dei Pittori Fiorentini*, Vol.2, 1961, no.2509 D. **2.** See A. Scharf, *Luca Signorelli (1441–1523)*, Old Master Drawings, Vol.14, September–March 1939–40, p.50 and pl.46 and *A Catalogue of Pictures and Drawings from the Collection of Sir Thomas Merton, F.R.S.*, 1950, no.22; B. Berenson, *op. cit.*, no.2509 E–12 and *Mostra di Luca Signorelli, op. cit.* The falling figures in the bottom left of the fresco of the *End of the World* are particularly comparable, see B. Berenson, *Italian Pictures of the Renaissance Central Italian and North Italian Schools*, Vol.2, 1968, pl.953. **3.** It was quite common for Signorelli to use the same design more than once. The two versions of Signorelli's *Virgin and Child* at the Metropolitan Museum and the Walker Art Gallery were based on the same cartoon, see R. Fastnedge, *A Restored Work by Signorelli at Liverpool*, The Burlington Magazine, Vol.95, August 1953, p.273ff. **4.** M. Evans, *A Signorelli drawing for Liverpool*, The Burlington Magazine, Vol.123, July, 1981, p.440. See, for example, the soldier to the left of Christ in Signorelli's fresco of the *Flagellation* in San Crescentio, Morra. See P. Scarpellini, *Luca Signorelli*, 1964, pp.62, 125, 136, 293 and pl.93. Figures in a similar pose appear in two other paintings associated with Signorelli, in Venice, Ca' d'Oro and Rome, coll. Tartaglia. See *Mostra di Luca Signorelli, op. cit.*, nos.60 and 63. **5.** Collector's mark (Lugt 2445) in bottom left corner. **6.** M. Evans, *op. cit.* Most of Lawrence's drawings passed to Woodburn. Lot 848 is described thus in the catalogue: *848 SIGNORELLI (L) – The figure of a young man in attitude of defiance – black and white chalk* (followed by) *GOZZOLI (B) – Two studies of dogs.* **7.** See Francis Russell, *letter*, 24 April 1981. **8.** See Francis Russell, *letter*, 14 April 1981. **9.** No.9883 was previously offered for sale but withdrawn, Christie's, 11 December 1979, lot 27.

STEIGER, Isabel de, active 1879–1926

9348 Arabs in an alcove

Watercolour, 6.4×6.4

Signed: *I. de S.*

No.9348 is one of thirty-two small watercolours all occupying the white

squares of a chessboard; the watercolours were commissioned by Philip Henry Rathbone (1828–1895) for whom the chessboard was made.[1] The earliest dated watercolours were painted in 1875 and the latest dated watercolour was painted in 1888. See also pp.26 and below.

Prov: Philip H. Rathbone; by descent to Miss Diana M. Moore who presented it to the Walker Art Gallery 1978.

Ref: **1.** Major W. A. M. Moore, note on the origin of the chessboard of 11 September 1953; the artists of the watercolours were usually friends or guests of Rathbone; for Rathbone see Edward Morris, *Philip Henry Rathbone and the purchase of contemporary foreign paintings for the Walker Art Gallery, Liverpool, 1871–1914,* Annual Report and Bulletin of the Walker Art Gallery, 1975–1976, Vol.6, pp.59ff.

WESTHOFEN, W., active late 19th century

9327 Country Lane with Figure

Watercolour, 6.4×6.4

Signed: *W.W./1875*

9340 Fir-lined river near mountains

Watercolour, 6.4×6.4

Signed: *W.W./75*

9344 River Scene by Moonlight

Watercolour, 6.4×6.4

Signed: *W.W./75* (or *6*)

Nos.9327, 9340 and 9344 are three of thirty-two small watercolours all occupying the white squares of a chessboard; the watercolours were commissioned by Philip Henry Rathbone (1828–1895) for whom the chessboard was made.[1] The earliest dated watercolours were Nos.9327, 9340 and 9344, and the latest dated watercolour was painted in 1888. Westhofen exhibited a watercolour *Calm of Evening* at the 1878–1879 Society of British Artists exhibition (No.542); otherwise nothing seems to be known about him. See also pp.26, 30.

Prov: Philip H. Rathbone; by descent to Miss Diana M. Moore who presented it to the Walker Art Gallery 1978.

Ref: **1.** Major W. A. M. Moore, note on the origin of the chessboard of 11 September 1953; the artists of the watercolours were usually friends or guests of Rathbone; for Rathbone see Edward Morris, *Philip Henry Rathbone and the purchase of contemporary foreign paintings for the Walker Art Gallery, Liverpool, 1871–1914,* Annual Report and Bulletin of the Walker Art Gallery, 1975–1976, Vol.6, pp.59ff.

WILCZYNSKI, Katerina, 1894–1978

9738 Sepulveda

Pen, ink and watercolour, 41.5×52.5

Signed: *WILC/47*

Inscribed: *SEPULVEDA*

Sepulveda is near Segovia in Spain.

9739 San Francisco Acatepec

Bamboo pen and ink, 47×35.5

Signed: *WILC/7/1/58*

Inscribed: *SAN FRANCISCO ACATEPEC/(MEXICO)*

In No.9739 elements from the façade of San Francisco Acatepec[1] have been re-arranged by the artist[2]; the 18th century *poblano* style church decorated with polychrome tiles is near Puebla in Mexico.

Exh: New Art Centre, 41 Sloane Street, London, *Katerina Wilczynski,* 1980 (13).

Ref: **1.** There are two illustrations of the façade in Justino Fernandez, *Mexican Art,* 1965, pls.37–38. **2.** She discusses her architectural fantasies in the introduction to the Berlin, Staatlichen Museen, Kunstbibliothek, 1975 Catalogue, *Katerina Wilczynski.*

9740 Delphi, hills

Pen, ink and watercolour, 45×59.5

No.9740 should be compared with the Delphi drawings reproduced in K. Wilczynski, *Homage to Greece,* ed. Andrews, 1964, pp.17–37. Delphi and Delos were the two places in Greece which most appealed to the artist.

Exh: New Art Centre, 41 Sloane Street, London, *Katerina Wilczynski,* 1980 (20).

Ref: **1.** See particularly the artist's introduction to the Berlin, Staatlichen Museen, Kunstbibliothek 1975 Catalogue, *Katerina Wilczynski* and C. M. Kauffmann in New Art Centre, *Katerina Wilczynski,* 1980, for the artist's reaction to Delphi and its landscape; the artist visited Greece frequently between 1952 and 1971.

Prov: (9738–9740) Presented by the artist's executors 1980.

CATALOGUE OF SCULPTURE

BARTOLINI, Lorenzo, 1777–1850

L679 Charity

Marble, height 155 (with base)

Inscribed: *BARTOLINI*

A much damaged and reduced version of *La Carità (La Carità Educatrice)* of 1817–1824 now in the Palazzo Pitti, Florence; the plaster model is in the Gipsoteca Bartoliniana, Florence.[1]

Prov: Richard Vaughan Yates who presented it to the Liverpool Mechanics Institution before 1840[2]; lent by the Governors of the Liverpool Institute School for Girls, Blackburne House.

Exh: Liverpool Mechanics Institution, *Exhibition of Objects Illustrative of the Fine Arts, etc.,* 1840, No.337, as *Maternal Affection* by an unknown artist.[3]

Ref: **1.** M. Tinti, *Lorenzo Bartolini,* 1936, Vol.2, pp.44–6, plate 39; Prato, Palazzo Pretorio, *Lorenzo Bartolini,* 1978, p.42, No.10; there is also at the Gipsoteca Bartoliniana a smaller plaster model for this group from which L679 may have been made – see Prato, *op. cit.,* p.42 and p.303, No.11; this smaller plaster model (dep.1884, San Salvi 42; inv. sculture 1260) was severely damaged in the 1966 floods and is now in several pieces. **2.** H. J. Tiffen, *A History of the Liverpool Institute School for Boys,* 1935, p.168, gives the date as before 1841 but the 1840 Liverpool Mechanics Institution Catalogue (see under *Exhibited* above) states that *Maternal Affection* had then already been presented to the Institution by R. V. Yates. **3.** *Maternal Affection* was also exhibited at the 1842 and 1844 Liverpool Mechanics Institution *Exhibitions* (p.61 and No.63); in 1844 it was attributed to Bartolini.

BAZZANTI, P. & Co., mid 19th century

L447 The Young Linnaeus

Marble, height 76

Signed: *P. Bazzanti*
 Florence

The traditional title has recently been confirmed.[1] It was formerly believed that the Swedish botanist Carl Linné (1707–1778), known as Linnaeus, made little progress with his school studies because his interests were already centred on botany and that his father proposed to apprentice him to a shoe-maker.[2] This identification is consistent with the pose and attributes of L447: a young boy, sitting pensively, his eyes averted from the school book on his lap. He wears a workman's apron and holds a bunch of flowers in his right hand. On the base are more flowers, a pair of shoes with formers in them, a hammer, the blade of a spade and a ball of yarn or twine.

The Bazzanti workshop in Florence was founded in 1822 near the Palazzo Corsini and was run by members of the family until 1925; an art gallery specialising in sculpture still does business under the name *Pietro Bazzanti & Figlio* on the Lungarno Corsini.[3] Pietro (or Pierre) Bazzanti executed the tomb of Lady Sophia Pierrepont at Holme Pierrepont, Nottinghamshire in 1823 and Niccolò (or Nicholas) Bazzanti executed the tomb of Isabella Cave at Henbury, Gloucestershire in 1827 and that of Mary Jones at South Stoneham, Hampshire in 1829.[4] Niccolò also carved the marble statue of Orcagna at the Uffizi in 1843.[5] In 1861 the company P. Bazzanti exhibited a wide range of sculptures at the *Prima Esposizione Nazionale di Firenze*.[6] The 1867 John Murray *Handbook for Travellers in Central Italy* states: 'Bazzanti, on the Lung'arno Corsini, can be recommended for sepulchral monuments, having put up many of those in the Protestant cemetery: he also keeps one of the largest warehouses in Florence for alabaster figures, vases, etc.'.[7]

Other sculptures signed P. Bazzanti include: *Benjamin Franklin with Whistle,* dated 1876, University of Pennsylvania collection; *Romeo and Juliet,* presented 1888, National Gallery of New South Wales, Sydney; *Venus Kneeling,* sold Sotheby's, 20 June 1979, lot 100; a *Pair of Alabaster Busts of Young Girls,* sold Sotheby's, 16 March 1977, lot 68, and an *Alabaster Figure of a Fisher Girl,* sold Sotheby's, 10 May 1978, lot 143.[8] The style and quality of these sculptures varies and it seems likely that they were produced by various hands within the workshop over a period stretching from the middle to the end of the nineteenth century. The signature, *P. Bazzanti* may be that of the workshop as a whole, rather than that of its head or one of the sculptors who worked within it.[9]

Prov: Acquired by George Holt (1790–1861) or Robert Durning Holt (1832–1908) c.1851–1862,[10] remained at Holt House, from which lent to Sudley Art Gallery, October 1979.

Ref: **1.** For the traditional title, see George Holt, *letter,* September 1983. Confirmed by Prof. Allan Ellenius, *letter,* 17 November 1983. **2.** For a summary of the life of Linnaeus, see *Encyclopaedia Britannica,* 11th ed., 1911, p.732. **3.** See R. Gunnis, *Dictionary of British Sculptors 1660–1851,* 1953, p.43, V. Barducci, *letter,* 20 September 1983 and Dr. E. Spalletti, *letter,* 6 December 1983. **4.** See R. Gunnis, *op. cit.,* p.43. There is no record that either of the Bazzanti visited England. Niccolò was born in 1802. There is no known reference to the birthdate of Pietro in the Florentine archives. Dr. E. Spalletti, *letter,* 6 December 1983. **5.** See R. Gunnis, *op. cit.,* p.43. **6.** See Dr. E. Spalletti, *letter,* 6 December 1983. **7.** p.87. **8.** See *The University of Pennsylvania: Collector and Patron of Art 1779–1979,* 1979, no.1 as by P. Barzanti (sic) and *National Art Gallery of New South Wales Illustrated Catalogue,* 1927, no.48. **9.** See V. Barducci, *letter,* 20 September 1983. It has been supposed thaat the Pietro Bazzanti, whose name appears in references of the third quarter of the nineteenth century, was the son of Niccolò. See Dr. E. Spalletti, *letter,* 6 December 1983. If this is the case, the Pietro active in 1823 would be his namesake, possibly an uncle. Alternately, it is possible that there was only one Pietro, presumably the brother of Niccolò and head of the workshop, who was still alive in 1876, the date of the University of Pennsylvania *Benjamin Franklin with Whistle.* **10.** Traditionally acquired by one or the other at the London International Exhibitions of 1851 or 1862. See George Holt, *letter,* September 1983. L447 is not listed in the catalogues of either exhibition. L447 is listed in the inventory of the contents of 52 Ullet Road, Liverpool, compiled in October 1926 (ms. in Liverpool Record Office, Liverpool City Libraries, H.920. HOL 4/14).

CAVACEPPI, Bartolomeo, 1716–1799

10338 Statuette of a Muse

Marble, height 82

Only the lower part of the Muse's body below her waist is antique; the hands and arms are also modern[1]; Cavaceppi has restored the statuette as Hygeia.[2]

Prov: Bartolomeo Cavaceppi[3]; Henry Blundell; by descent to Colonel Joseph Weld who presented it 1959.

Ref: **1.** Bernard Ashmole, *A Catalogue of the Ancient Marbles at Ince Blundell Hall*, 1929, p.32, No.68, plate 23, and Seymour Howard, *Bartolomeo Cavaceppi*, 1982, pp.78, 250, No.4, figs.177–178. **2.** (Henry Blundell) *An Account of the Statues, Busts, etc., at Ince. Collected by H.B.*, 1803, p.18, No.21. **3.** Blundell, *op. cit.*

10340 Bust of a Woman

Marble, height 98

Ashmole described the bust of No.10340 as modern and even the head as 'not above suspicion'; it is modelled on a fourth century B.C. type represented by a head in the Glyptotek, Munich (Inv. 249a (476)).[1] Howard saw parts of the head and bust of No.10340 as antique but conceded that restoration had been drastic and the entire surface abraded and smoothed.[2]

Blundell described No.10340 as a Muse 'from the chasteness of the drapery'.[3]

Prov: ?Barberini Palace[4]; Bartolomeo Cavaceppi[5]; Henry Blundell; by descent to Colonel Joseph Weld who presented it 1959.

Ref: **1.** Bernard Ashmole, *A Catalogue of the Ancient Marbles at Ince Blundell Hall*, 1929, p.60, No.146, plate 13. **2.** Seymour Howard, *Bartolomeo Cavaceppi*, 1982, pp.80–81, 250, No.11, figs.193–196. **3.** (Henry Blundell) *An Account of the Statues, Busts, etc., at Ince. Collected by H.B.*, 1803, p.44, No.96. **4.** Blundell, *op. cit.* **5.** Blundell, *op. cit.*

DUPUIS, Jean Baptiste Daniel, 1849–1899, after

9725 Medal of the Société des artistes français

Metal, diameter 5.4

Signed: *DANIEL DUPUIS*

Inscribed: *SOCIETE DES ARTISTES FRANCAIS/PEINTURE/ SALON DE 1835/NEALE/G. HALL/AD GLORIAM/ARS/LONG/ VITA*

George Hall Neale (active 1883–1940) won a silver medal at the 1935 *Société des Artistes français* Paris exhibition with his *Portrait of Ernest*

Makower, Catalogue No.1718. The design for the *Société des Artistes français* medal dates from 1885.[1]

Prov: Found in the Gallery 1980.

Ref: **1.** L. Forrer, *Biographical Dictionary of Medallists*, 1904, Vol.1, p.328; S. Lami, *Dictionnaire des sculpteurs de l'école française au dix-neuvième siècle*, 1916, Vol.2, p.255.

DUQUESNOY, François, 1594–1643, after

9478 Musical Putti

Plaster cast, field tinted blue, 82.3×222

A cast after Duquesnoy's relief which forms part of the decoration of the altar in the Filomarini Chapel in SS. Apostoli, Naples, installed in 1641/42.[1]

Prov: Unknown. Found in the Gallery in 1978.

Ref: **1.** M. Fransolet, *François du Quesnoy*, 1942, pp.115–17 and pl.25.

ESTE, Antonio d', 1754–1837

10335 Bust of Claudius

Marble, height 74

Poulson[1] and, with reservations, Ashmole[2] regarded this bust as entirely modern.

Prov: Antonio d'Este[3]; Henry Blundell; by descent to Colonel Joseph Weld who presented it 1959.

Ref: **1.** P. F. S. Poulsen, *Greek and Roman Portraits in English Country Houses*, 1923, p.19. **2.** Bernard Ashmole, *A Catalogue of the Ancient Marbles at Ince Blundell Hall*, 1929, p.53, No.124, plate 32. **3.** (Henry Blundell) *An Account of the Statues, Busts, etc., at Ince. Collected by H.B.*, 1803, p.62, No.158; according to Blundell No.10335 was 'found in some ruins near the Palatine hill'. See also *Engravings and Etchings of the Principal Statues etc., in the Collection of Henry Blundell at Ince*, 1809, plate 69, No.1.

GIRARDON, François, 1628–1715, after

9466 Allegorical Figure

Plaster cast, 147×64

Inscribed: (stamp) *L. Mathivet*

A cast after a marble relief by Girardon, executed as part of a funerary monument to Anne Marie Martinozzi, princess de Conti, between 1672 and 1675.[1] The figure's right hand originally rested upon an anchor, symbolic of Hope and its left hand held a flaming heart, symbolic of Faith.

The former was cut away and the latter re-carved into a poppy in 1807 when the monument was sent to Malmaison as a park decoration. In 1884–1890 the sculpture was lent to the museum of the Union centrale des art décoratifs in Paris, now known as the Musée des arts décoratifs. It seems likely that No.9466 was cast during this period. In 1939 Girardon's marble relief was acquired by the Metropolitan Museum in New York.

Prov: Unknown. Found in the Walker Art Gallery in 1978.

Ref: 1. For a summary of the history of Girardon's relief, see P. Remington, *Recent Acquisitions of French Sculpture,* Bulletin of the Metropolitan Museum of Art, vol.34, September, 1939, no.9, pp.214–15 and pl. on cover.

ITALIAN School, 18th century

10333 Bust of Julius Caesar

Marble, height 62

No.10333 was described by Poulsen as a modern forgery[1] and by Michaelis[2] as of 'doubtful genuineness', but Ashmole saw it as largely antique.[3]

Prov: Henry Blundell[4]; by descent to Colonel Joseph Weld who presented it 1959.

Ref: 1. P. F. S. Poulsen, *Greek and Roman Portraits in English Country Houses,* 1923, p.19. 2. A. Michaelis, *Ancient Marbles in Great Britain,* 1882, p.361, No.101. 3. Bernard Ashmole, *A Catalogue of the Ancient Marbles at Ince Blundell Hall,* 1929, p.46. No.101, plate 33. 4. (Henry Blundell) *An Account of the Statues, Busts etc., at Ince. Collected by H.B.,* 1803, p.50, No.115.

10336 Bust of the Emperor Caracalla

Marble, height 58

A copy after the antique bust at the Museo Nazionale, Naples.[1]

Prov: Henry Blundell[2]; by descent to Colonel Joseph Weld who presented it 1959.

Ref: 1. A. Ruesch, *Guida Illustrata del Museo Nazionale di Napoli,* 1908, p.235, No.979 (see also F. Haskell and N. Penny, *Taste and the Antique,* 1981, p.172, No.18) – as noted by Bernard Ashmole, *A Catalogue of the Ancient Marbles at Ince Blundell Hall,* 1929, p.80, No.217. 2. (Henry Blundell) *An Account of the Statues, Busts etc., at Ince. Collected by H.B.,* 1803, p.188, No.552. From its position in Blundell's *Account,* No.10336 must have been acquired in 1800–1802, but it was not bought at Lord Mendip's Sale as Ashmole, *op. cit.,* asserts.

10337 Bust of Homer

Marble, height 56

No.10337 is a free copy after the antique bust in the Museo Nazionale, Naples.[1]

Prov: Henry Blundell[2]; by descent to Colonel Joseph Weld who presented it 1959.
Ref: 1. A. Ruesch, *Guida Illustrata del Museo Nazionale di Napoli,* 1908, p.268, No.1130

as noted by Bernard Ashmole, *A Catalogue of the Ancient Marbles at Ince Blundell Hall*, 1929, p.67, No.168; this is the Hellenistic or Blind Type – see G. M. A. Richter, *The Portraits of the Greeks*, 1965, Vol.1, pp.50ff., particularly p.50, No.7, for the Naples bust; Richter, *op. cit.*, p.52, lists No.10337 as a modern copy of the Hellenistic or Blind Type; Ashmole, *op. cit.* and Whitworth Art Gallery, *Richard Payne Knight*, 1982, p.142, No.58, both wrongly identify No.10337 with (Henry Blundell) *An Account of the Statues, Busts etc., at Ince. Collected by H.B.*, 1803, pp.64–65, No.166; it must be Blundell, *op. cit.*, p.188, No.553. **2.** From its position in Blundell, *op. cit.*, No.10337 must have been acquired in 1800–1802.

10339 Bust of a Woman with a Veil

Marble, height 63

Prov: Henry Blundell(?); by descent to Colonel Joseph·Weld who presented it 1959.

10341 Bust of Homer

Marble, height 25

No.10341 appears to be an antique example of the Hellenistic or Blind type[1]; however, Poulsen described it as modern.[2]

Prov: Henry Blundell; by descent to Colonel Joseph Weld who presaented it 1959.

Ref: **1.** G. M. A. Richter, *The Portraits of the Greeks*, 1965, Vol.1, p.51, No.15. Bernard Ashmole, *A Catalogue of the Ancient Marbles at Ince Blundell Hall*, 1929, p.50, No.115, plate 29. **2.** P. F. S. Poulsen, *Greek and Roman Portraits in English Country Houses*, 1923, p.19; the bust part is certainly modern. **3.** (Henry Blundell) *An Account of the Statues, Busts, etc., at Ince. Collected by H.B.*, 1803, p.60, No.151; see also *Engravings and Etchings of the Principal Statues, etc., at Ince*, 1809, plate 64.

10342 Female Hand

Marble, height 58 (with supporting column, sphere and base)

No.10342 was attributed in 1982 to Bartolomeo Cavaceppi[1] who certainly provided Blundell with another marble hand[2]; Blundell admired the fleshiness and softness of No.10342.[3]

Prov: Henry Blundell[4]; by descent to Colonel Joseph Weld who presented it 1959.

Ref: **1.** Whitworth Art Gallery, Manchester, *Richard Payne Knight*, 1982, No.57, p.142, where the hand is both attributed to Cavaceppi and described as antique; Bernard Ashmole, *A Catalogue of the Ancient Marbles at Ince Blundell Hall*, 1929, does not mention No.10342 and so he presumably regarded it as modern. **2.** (Henry Blundell) *An Account of the Statues, Busts, etc., at Ince. Collected by H.B.*, 1803, p.151, No.420. **3.** Blundell, *op. cit.*, p.152, No.422, who evidently saw No.10342 as a fragment of an antique statue. **4.** Blundell, *op. cit.*, p.152, No.422, the Whitworth Art Gallery, *op. cit.*, describes the column of No.10342 as made of imperial porphyry while Blundell, *op. cit.*, states that the column of his No.422 was 'a fine specimen of grey granite'.

10344 Head and shoulders of Hercules

Marble, height 21 and 16

According to Blundell No.10344 was found at Lunghezza[1] but Ashmole described it as modern.[2] The head and shoulders are now separate (and were already separate in 1929).[3]

Prov: Henry Blundell; by descent to Colonel Joseph Weld who presented it 1959.

Ref: **1.** (Henry Blundell) *An Account of the Statues, Busts etc., at Ince. Collected by H.B.,* 1803, pp.57–58, No.142. **2.** Bernard Ashmole, *A Catalogue of the Ancient Marbles at Ince Blundell Hall,* 1929, p.66, No.163, plate 24. **3.** Ashmole, *op. cit.* Blundell only refers to a head under his No.142.

10345 Bust of Quintus Aristaeus

Marble, height 33

Inscribed: *DM | T.F.QVARISTAEO | ANTESPORVSDOMINOS | BENEMERENTIDESVO | IMAGINEMCONSACRAV*

No.10345 was described by Poulsen as a forgery[1] although Ashmole says 'not necessarily a forgery'.[2] The inscription, which Ashmole saw as modern, was translated by Blundell thus: 'To the domestic Gods; To Quintus Aristaeus, the son of Titus, his Master, Well deserving of his Friends, Antesphorus consecrated this image'.[3]

Prov: Henry Blundell[4]; by descent to Colonel Joseph Weld who presented it 1959.

Ref: **1.** P. F. S. Poulsen, *Greek and Roman Portraits in English Country Houses,* 1923, p.19. **2.** Bernard Ashmole, *A Catalogue of the Ancient Marbles at Ince Blundell Hall,* 1929, p.79, No.214, plate 35. **3.** (Henry Blundell) *An Account of the Statues, Busts, etc., at Ince. Collected by H.B.,* 1803, p.145, No.410. **4.** Blundell, *op. cit.*

10346 Boar and two dogs

Marble relief, 21×35

No.10346 is described by Ashmole as 'perhaps entirely modern'.[1]

Prov: Henry Blundell[2]; by descent to Colonel Joseph Weld who presented it 1959.

Ref: **1.** Bernard Ashmole, *A Catalogue of the Ancient Marbles at Ince Blundell Hall,* 1929, p.116, No.384, plate 48. **2.** (Henry Blundell) *An Account of the Statues, Busts etc., at Ince. Collected by H.B.,* 1803, p.99. No.301.

10347 Bust of Apollo or Venus

Marble, height 44

No.10347 was attributed by Blundell to Guglielmo della Porta (without much confidence).[1] Ashmole described it as 'perhaps modern'.[2]

Prov: Henry Blundell; by descent to Colonel Joseph Weld who presented it 1959.

Ref: **1.** (Henry Blundell) *An Account of the Statues, Busts etc., at Ince. Collected by H.B.,* 1803, p.69, No.184. **2.** Bernard Ashmole, *A Catalogue of the Ancient Marbles at Ince Blundell Hall,* 1929, p.78, No.209, plate 24.

10348 Bust with double veil

Marble, height 54

Both Ashmole[1] and Howard[2] state without evidence that No.10348 came from the studio of Bartolomeo Cavaceppi; Ashmole suggests; 'perhaps modern' and notes that none of the ancient surface is left; Howard observes: 'so drastically re-worked as to be no longer ancient in its essential forms if not modern from the outset' and he attributes the restoration (or creation) of No.10348 to Cavaceppi or his studio.[3] The hairdressing of No.10348 imitates that of a Vestal Virgin.[4]

Prov: Henry Blundell[5]; by descent to Colonel Joseph Weld who presented it 1959.

Ref: **1.** Bernard Ashmole, *A Catalogue of the Ancient Marbles at Ince Blundell Hall,* 1929, p.77, No.207, plate 24. **2.** Seymour Howard, *Bartolomeo Cavaceppi,* 1982, p.83. **3.** Howard, *op. cit.,* p.251, No.27. **4.** Ashmole, *op. cit.*; (Henry Blundell) *An Account of the Statues, Busts etc., at Ince. Collected by H.B.,* 1803, p.80, No.228 describes No.10348 as a Vestal Virgin. **5.** Blundell, *op. cit.*

ITALIAN School, 18th or 19th century

10334 Head of Lucius Verus

Marble, height 69

No.10334 is described by Ashmole as an early 19th century copy or forgery.[1]

Prov: Henry Blundell[2](?); by descent to Colonel Joseph Weld who presented it 1959.

Ref: **1.** Bernard Ashmole, *A Catalogue of the Ancient Marbles at Ince Blundell Hall,* 1929, p.41, No.84a, plate 39. **2.** Ashmole, *op. cit.,* p.136 identifies No.10334 with (Henry Blundell) *An Account of the Statues, Busts etc., at Ince. Collected by H.B.,* 1803, p.45, No.100, but Blundell's No.100 is certainly No.6538 already in the Walker Art Gallery – see Walker Art Gallery, *Foreign Catalogue,* 1977, p.284 under Carlo Albacini – as the base of No.6538 is inscribed *100.* No other bust of Lucius Verus seems to be listed in Blundell *op. cit.,* so No.10334 would seem to have been acquired after 1803.

KAPOOR, Anish, born 1954

10361 Red in the Centre

Bonded earth over polystyrene core; oil glaze and red pigments, height (of five components, from left: see photograph) 71.0, 35,0, 21.0, 32.0 and 58.0

From Spring 1982 until Spring 1983 Anish Kapoor was second artist in residence on Merseyside, based at the Bridewell studios in Liverpool. No.10361 was executed during this period, and is dated 1982.

Kapoor's earliest sculptural installations of this type consisted of forms made entirely of chalk powder and powder pigments. Later groups, such as *Part of the Red,* 1981, which is comprised of five floor pieces, have a

solid core.[1] As the surfaces of these sculptures are entirely covered in evenly sprinkled dry powder pigments, they have to be re-made each time they are shown: a process with symbolic overtones for the artist.[2] In No.10361 sprinkled dry powder pigment is added only to the wall component and part of the floor piece, second from the left (see photograph).

The artist creates such sculptural installations intuitively, selecting and arranging the individual components until a satisfactory arrangement is achieved. Once arrived at, the relative placing and distances from one another of the individual components are recorded in a diagram, to be followed whenever the piece is displayed.

In 1979, the artist visited India for the first time in seven years. His subsequent works, including No.10361, are informed by Hindu mythology, art and architecture. Kapoor has a particular interest in the goddess Kali, of whom he has stated: 'My sense of her is that she is completely benign, yet full of destruction. She is the great mother, the creator, the place of all creation, yet potentially the destroyer of everything'.[3] In this context, the use of the most basic and natural of substances, earth, in the coating of such works as No.10361 is particularly apposite.[4] It has been pointed out that the undulating red tongue-like wall component of No.10361 bears a direct relationship to images of Kali.[5] The combination of forms with threatening and erotic associations in No.10361 may be evocative of the dual aspect of this goddess, as both creator and destroyer. Kapoor's *Tongue,* 1982, which also consists of four floor pieces and a wall component, but which has deep blue and black polychromy has been described as a 'companion piece' to No.10361.[6] As the black pigmentation of this piece has been interpreted by the artist as the colour of creation, it is possible that the red colouring of parts of No.10361 is an allusion to the destructive aspect of Kali.[7]

Prov: Purchased from the artist, 1982.

Exh: *Anish Kapoor, as if to celebrate . . .,* Galerie 't Venster, Rotterdam, 1983, No.10; *Anish Kapoor Feeling into Form,* Walker Art Gallery, Liverpool and Le Nouveau Musée, Lyon, 1983.

Ref: **1.** See M. Livingstone, *Anish Kapoor Feeling into Form,* 1983, p.11 and pl. facing p.25. **2.** 'Like all of Kapoor's work of that time it had to be remade each time it was shown, a ritualistic re-enactment of the process which had brought it into being. Its transcience as a thing of the world was central to its meaning, just as the precedence of the process of making over the finite objects that resulted defined the triumph of spirit over matter'. See M. Livingstone, *op. cit.,* p.8. **3.** From an interview given on 3 January 1983. See M. Livingstone, *op. cit.,* p.23. **4.** 'Mud, he (i.e. Kapoor) reminds us, is the most suitable material for representing the earth goddess and has long been used for this purpose in many cultures'. See M. Livingstone, *op. cit.,* p.27. **5.** By M. Livingstone, *op. cit.,* p.25. **6.** Also in the exhibition *Anish Kapoor Feeling into Form,* but not illustrated in the catalogue. See M. Livingstone, *op. cit.,* pp.23 and 25. **7.** Kapoor's colour symbolism does not adhere to a rigorous system. See M. Livingstone, *op. cit.,* p.25: 'The fearsome black of the accompanying work (i.e. *Tongue,* 1982) is interpreted by Kapoor not as the colour of destruction but as that of creation, like the mud from which the objects beneath are made' and p.17: 'In the first powder works Kapoor began to work out a colour symbolism, with red, a favourite colour, representing the male and the generative. White he saw as female or as signifying purity, yellow as desire (the passionate part of red) and blue as the godly part of red. Kapoor is the first to admit that his is not a rigorous system, and that the meaning and function of colour, like those of form, is apt to change from work to work. Red may as easily define a female breast form as a phallic male one; a colour can have a highly specific meaning for him in one work and a very different significance in another one'.

ROBBIA, Andrea della, 1435–1525, after

9448 Madonna and Child with God the Father, the Holy Ghost and angels

Plaster cast, 99×56

A cast after Andrea della Robbia's glazed terracotta relief, formerly in the collection of M. Emile Gavet, Paris, and in 1922 in the Mrs. O. H. P. Belmont collection, Newport, Rhode Island.[1]

Prov: Unknown. Found in the Walker Art Gallery in 1978.
Ref: **1.** A. Marquand, *Andrea della Robbia and his Atelier,* Vol.1, 1922, pp.6–7

ROBBIA, Luca della, 1400–1482, after

9458 Players on the Psaltery
Plaster cast, field tinted blue, 121×102
Inscribed: (top left) *1 D BRUCCIANI AND CO. LONDON*

9477 Drummers and Dancing Children
Plaster cast, field tinted blue, 121×101.6
Inscribed: (top left) *2 D BRUCCIANI AND CO. LONDON*

9474 Trumpeters and Dancing Children
Plaster cast, field tinted blue, 121×102.5
Inscribed: (top left) *3 D BRUCCIANI*

9459 Players on the Cithera
Plaster cast, field tinted blue, 121.5×102
Inscribed: (top left) *4 D BRUCCIANI AND CO. LONDON*

Casts after the four panels, illustrative of Psalm 150, from the upper register of Luca della Robbia's marble *Cantoria* of 1431–37, formerly in the Cathedral of Santa Maria dei Fiore and now in the Museo dell'Opera del Duomo, Florence.[1] Domenico Brucciani (1815–80) was born in Lucca, set up business in Russell Street, Covent Garden in 1837, and by 1864 had a considerable stock of plaster casts of famous pieces of sculpture.[2] He supplied many casts to art schools and the South Kensington Museum (subsequently, the Victoria and Albert Museum). There is a cast of the whole of Luca della Robbia's *Cantoria* in the Cast Court of the Victoria and Albert Museum, supplied by the Florentine Oronzio Lelli in 1877.

Prov: Unknown. Found in the Gallery in 1978.
Ref: **1.** See J. Pope-Hennessy, *Luca della Robbia,* 1980, pp.225–31 and pls.5, 10, 2 and 7. **2.** For a summary of Brucciani's activities, see M. Baker, *A Glory to the Museum The Casting of the 'Portico de la Gloria',* The Victoria and Albert Album, 1, 1982, pp.104–06.

VERROCCHIO, Andrea del, *c.*1435–1488, after

9508 Madonna and Child

Plaster cast, 51×39.5

A cast after a marble relief in the Bargello, associated with the style of Verrocchio, of which there are numerous replicas, some as early as the fifteenth century in date.[1]

Prov: Unknown. Found in the Walker Art Gallery in 1978.

Ref: **1.** Pointed out by Anthony Radcliffe, *letter* of 14 July 1983. See T. A. Cook, *Leonardo da Vinci Sculptor,* 1923, pp.24–37 and figs. between pp.24 and 25 and G. Passavant, *Verrocchio Sculptures, Paintings and Drawings,* 1969, pp.206–207 and App.17–20. Of known replicas, the gesso cast in the Rijksmuseum, Amsterdam (T. A. Cook, *op. cit.,* pp.28–29 and fig.D) is the most like No.9508.

CATALOGUE OF PRINTS AND PHOTOGRAPHS

ALBERS, Joseph, 1888–1976

9243 Olympische Spiele München 1972

Colour offset lithograph, 101×64.1

Signed: (lower right, in the plate) *Albers '70*

Inscribed: *Olympische Spiele München 1972* with Olympic symbol above official emblem of the 20th Olympiad/*c EDITION OLYMPIA 1972 GmbH 1971/Printed in Germany*

From five series, each of seven posters all by different artists, advertising the Olympic Games held in Munich, 26 August to 10 September 1972. The first series comprised posters designed by Hans Hartung,[1] Oskar Kokoschka,[2] Charles René Lapicque,[3] Jan Lenica, Marino Marini, Serge Poliakoff and Fritz Winter.[4] The second series comprised posters designed by Horst Antes,[5] Shusaku Arakawa,[6] Eduardo Chillida,[7] Piero Dorazio,[8] Allen Jones,[9] Pierre Soulages[10] and Victor Vasarely[11] (who also designed the official emblem of the 20th Olympiad). The third series comprised posters designed by Josef Albers,[12] Otmar Alt,[13] Max Bill,[14] Allan D'Arcangelo,[15] David Hockney[16] R. B. Kitaj,[17] and Tom Wesselmann.[18] The fourth series comprised posters designed by Valerio Adami, Alan Davie, F. Hundertwasser, Jacob Lawrence, Peter Phillips, Richard Smith and Paul Wunderlich. The fifth series comprised posters designed by Gernot Bubenik, Günter Desch, Alfonso Hüppi, Kleinhammes, Werner Nöfer, Wolfgang Petrick, E. G. Willikens and Gerd Winner.[19] The posters were issued jointly by the Organising Committee for the Games of the 20th Olympiad and the publishing house F. Bruckmann KG, Munich in 1969–1972.

The posters were issued in three grades:
1. *Original graphic works.* Lithographs and serigraphs, each individually signed and numbered by the artist, in limited editions of 200 each.
2. *Original posters.* Printed in the same way as the *original graphic works* but on lighter paper. Signed on the stone or in the screen, but not hand signed or numbered. The editions were limited to 4000 (Kokoschka's poster and the entire fifth series were not produced in this grade).[20]
3. *Art posters.* Produced commercially in unlimited editions.[21] The posters in the collection of the Walker Art Gallery are of this grade.

Prov: Purchased by the Walker Art Gallery Education Service, *c.*1971/73.

Ref: **1.** Walker Art Gallery, No.9250; see p.50. **2.** Walker Art Gallery, No.9244; see p.51. **3.** Walker Art Gallery, No.9246; see p.51. **4.** Walker Art Gallery, No.9259; see p.55. **5.** Walker Art Gallery, No.9248; see p.45. **6.** Walker Art

Gallery, No.9260; see p.45. **7.** Walker Art Gallery, No.9258; see p.48. **8.** Walker Art Gallery, No.9249; see p.49. **9.** Walker Art Gallery, No.9247. **10.** Walker Art Gallery, No.9256; see p.53. **11.** Walker Art Gallery, No.9245; see p.53. **12.** Walker Art Gallery, No.9243; see p.44. **13.** Walker Art Gallery, No.9255; see p.45. **14.** Walker Art Gallery, No.9253; see p.46. **15.** Walker Art Gallery, No.9251; see p.48. **16.** Walker Art Gallery, No.9254. **17.** Walker Art Gallery, No.9252; see p.50. **18.** Walker Art Gallery, No.9257; see p.54. **19.** For the Olympic posters in general, see H. Hohenemser, *Edition Olympia mit weltweitem Effekt,* 1972; E. Pfeiffer-Belli, *Im Studio Bruckmann: Die Künstler und ihre Arbeit,* Olympia in München, Official Issue for the Olympic City of Munich, 1972, pp.70–74 and 92–93 and T. Koch, *Piktogramm der Spiele pictogram of the games,* 1973. T..Koch, *op. cit.,* pp.VIII and XVIII, suggests that the fifth series was commissioned subsequently, primarily with young artists in mind, as the majority of the artists represented in the first four series were over forty years of age. **20.** There are complete runs of series 1–3 of this grade (with the exception of Kokoschka's poster which was not issued in this grade) in the Hunterian Art Gallery, University of Glasgow. **21.** There are complete runs of series 1 and 2 of this grade in the Department of Prints and Drawings and Photographs at the Victoria and Albert Museum.

ALT, Otmar, born 1940

9255 Olympische Spiele München 1972

Colour offset lithograph, 101×64.1

Signed: (lower right in the plate) *Otmar Alt 70*

Inscribed: *Olympische Spiele München 1972* with Olympic symbol above official emblem of the 20th Olympiad/c *EDITION OLYMPIA 1972 GmbH 1971/Printed in Germany*

See entry for ALBERS, Joseph, No.9243, p.44.

ANTES, Horst, born 1936

9248 Olympische Spiele München 1972

Colour offset lithograph,-101×64.1

Signed: (lower right, in the plate) *Antes*

Inscribed: *Olympische Spiele München 1972* with Olympic symbol above official emblem of the 20th Olympiad/c *EDITION OLYMPIA 1972 GmbH 1970/Printed in Germany*

See entry for ALBERS, Joseph, No.9243, p.44.

ARAKAWA, Shusaku, born 1936

9260 Olympische Spiele München 1972

Colour offset lithograph, 101×64.1

Signed: (lower right, in the plate) *Arakawa*

Inscribed: *Olympische Spiele München 1972* with Olympic symbol above official emblem of the 20th Olympiad/*c EDITION OLYMPIA 1972 GmbH 1970/Printed in Germany*

See entry for ALBERS, Joseph, No.9243, p.44.

BAUGNIET, Charles, 1814–1886

9720 Portrait of Thomas Berry Horsfall (1805–1878)

Lithograph, 44.5×34

Signed: (on stone) *C Baugniet/1860*

Inscribed: *THOMAS BERRY* (coat of arms) *HORSFALL ESQRE M.P./M & N HAWHART IMPT/Yours very faithfully Thomas B. Horsfall* (facsimile of autograph)

Baugniet spent many years in England and executed numerous prints of British sitters.[1] Thomas Berry Horsfall was a merchant, Mayor of Liverpool, 1847–8, and Conservative M.P. for Liverpool, 1853–1868. There is an oil portrait of Horsfall by George Patten (1801–1865) in the collection of the Walker Art Gallery (No.2167).[2] There is a duplicate of No.9720 in Liverpool Record Office.

Prov: Preston and Sandeman families, Ellel Grange, Galgate, Lancashire; Ellel Grange Sale, Christies' 22–23 October 1979 (209A) bt. for Walker Art Gallery.

Ref: **1.** U. Thieme and F. Becker, *Allgemeines Lexikon der Bildenden Künstler*, vol.3, 1909, pp.74–75. For a list of Baugniet's prints of British sitters at the British Museum (but not including a duplicate of No.9720) see H. M. Hake, *Catalogue of Engraved British Portraits Preserved in the Department of Prints and Drawings in the British Museum*, vol.6, 1925, pp.575–576. **2.** Walker Art Gallery, *Merseyside Painters, People & Places*, 1978, p.166 and pl.181 (No.2167).

BILL, Max, born 1908

9253 Olympische Spiele München 1972

Colour offset lithograph, 101×64.1

Signed: (upper right, in the plate) *Max Bill*

Inscribed: *Olympische Spiele München 1972* with Olympic symbol above official emblem of the 20th Olympiad/*c EDITION OLYMPIA 1972 GmbH 1971/Printed in Germany*

See entry for ALBERS, Joseph, No.9243, p.44.

CARTIER-BRESSON, Henri, born 1908

9743–9754 Liverpool 1962

Black and white photographs (archivally treated), 40.7×30.5

(Nos.9743, 9745, 9746, 9750, 9751) and 30.5×40.7 (Nos.9744, 9747–9749, 9752–9754)

Signed: (each, lower right, in ink) *Henri Cartier-Bresson*

Henri Cartier-Bresson visited Liverpool in 1962 in connection with an ABC Television programme *Tempo,* which was transmitted in 1963.[1] At the time, he made the following notes:

'Writing about the same people of the North at work amounts to the same as writing about them at play. Their looks are not so different neither are their clothes. There is no exhuberance on their faces nor gestures. Their vacationing seems just an occupation as any other. There appears no fulfillment as a human being; at work no gloom overcast only a little snide humour.

They are hard at it but in a sort of resigned way. Looking at compounds of offices, dwellings and factories it appears that work or living is not a very gay occupation. It is serious and dull and loads the everyday life. The weekends open their armoured gates and possibilities of an emergency exit wherever that may lead.

What more to say than to quote figures and statistics, i.e., for Liverpool Docks, so many tons of imports of such a raw material and so many tons of some other finished product. In between the people squeeze their poor lives, transforming things, doing it thoroughly; bringing quality and selling it elsewhere.

The same qualities appear during their working lives as when they are vacationing; a respect of each others privacy and in the same way to carry their noses close to their chins.

Apart from that one can see some new industrial expansion, but on the whole there is still very much feeling of the dragging of the 19th century. I look at it from the windshield of my camera in the same way as I have looked at other countries and try to make imprints. These pictures are the impression I have gained, to know more, books of economics could complement the pictures'.[2]

Cartier-Bresson did not identify the exact localities in which these photographs were taken, so some of the following descriptions are approximate. No.9743: Workmen laying a keel in Cammell Laird shipyard in Birkenhead. No.9744: Two boys in a street. No.9745: Children playing opposite St. Patrick's Chapel, Park Place. No.9746: A policeman and a pedestrian next to a refuse collection handcart in Hood Street. No.9747: Children passing ruined houses. No.9748: Prams outside a public washhouse; possibly in Lodge Lane. No.9749: Dockers outside the canteen in Gladstone Dock. No.9750: Men pushing a handcart across Commutation Road, with the base of the Wellington Monument in the background. No.9751: A man and a girl next to the statue of Michelangelo outside the Walker Art Gallery. No.9752: Keith Barnwell of Hull chasing Alan Davies of Wigan in a rugby league match at Central Park, Wigan; Wigan v Hull, League Game, Division 1, 20th October, 1962.[3] No.9753: A man raking leaves in a disused cemetery. No.9754: A woman with a pram, possibly in Everton.

The Cartier-Bresson negative numbers of Nos.9743–9754 are as follows:

8123 11A, 8124 16A, 8132 35A, 8135 11A, 8135 28A, 8124 35A, 8129 7A, 8130 1, 8130 42, 8133 4A, 8145 18, 8145 24. Nos.9743–9754 were printed during the Spring of 1980 from the original negatives. Henri Cartier-Bresson's archive of photographs at the Victoria and Albert Museum was exhibited at the Walker Art Gallery from 19 May until 1 July, 1979.[4]

Prov: Purchased from the photographer via the John Hillelson Agency Ltd., 1980, with the aid of a contribution from the Friends of Merseyside County Museums and Art Galleries.

Ref: **1.** John L. Hillelson, *letter*, 12 March 1980. That his visit took place in October of this year is apparent from the date of the rugby match depicted in No.9752 (see: above and note 3 below). **2.** 'Notes on the North' by Henri Cartier-Bresson, *typescript* supplied by John L. Hillelson, 12 March 1980 **3.** I am grateful to Cliff Webb for this identification, *verbally*, 29 July 1983. **4.** A touring exhibition, presented by the Scottish Arts Council in association with the Victoria and Albert Museum. This included a print from the same negative as No.9747 (cat. no.157). See Arts Council, *Henri Cartier-Bresson*, 1979.

CHILLIDA, Eduardo, born 1924

9258 Olympische Spiele München 1972

Colour offset lithograph, 101×64.1

Signed: (lower left, in the plate) *CHILLIDA*

Inscribed: *Olympische Spiele München 1972* with Olympic symbol above official emblem of the 20th Olympiad/c *EDITION OLYMPIA 1972 GmbH 1970/Printed in Germany*

See entry for ALBERS, Joseph, No.9243, p.44.

D'ARCANGELO, Allan, born 1933

9251 Olympische Spiele München 1972

Colour offset lithograph, 101×64.1

Signed: (lower right, in the plate) *A. D'Arcangelo 1970*

Inscribed: *Olympische Spiele München 1972* with Olympic symbol above official emblem of the 20th Olympiad/c *EDITION OLYMPIA 1972 GmbH 1971/Printed in Germany*

See entry for ALBERS, Joseph, No.9243, p.44.

DELACROIX, Ferdinand Victor Eugene, 1798–1863

9300 Hamlet and the body of Polonius

Lithograph, 22.5×17.7 (image)

Signed: *Eug. Delacroix/1835* (on plate)

Inscribed: *Vraiment ce conseiller est maintenant bien silencieux, bien discret, bien grave, lui qui dans sa vie était le drôle le plus bavard du monde./Lith de Villain.*

9372 The Queen tries to console Hamlet

Lithograph, 25.3×19.9 (image)

Signed: *1834/Eug. Delacroix* (on plate)

Inscribed: *Cher Hamlet, ecarte cette sombre apparence et jette un regard ami sur le roi./Lith de Villain.*

9393 The Death of Polonius

Lithograph, 24.1×19.2 (image)

Inscribed: *Qu'est ce donc? . . . Un rat!*

Three of the set of thirteen lithographs illustrating Shakespeare's *Hamlet* begun in 1834 and published by the artist in 1843; all three lithographs belong to the second state and come from the 1843 ecition.[1] No.9300 illustrates Act 3 Scene 4, No.9372 Act 1 Scene 2, and No.9373 Act 3 Scene 4.

Prov: Colonel Raymond C. Danson[2]; Nos.9372–3 only were in an anonymous Sale Sotheby's Belgravia, 26 May 1978, lot 141A part; presented by Iain Campbell 1978.

Ref: **1.** A. Robaut, *L'Œuvre Complet du Eugene Delacroix,* 1885, p.157 No.589, p.154 No.577, and p.156 Nos.586–587. L. Delteil, *Le Peintre Graveur Illustré,* Vol.3, 1908, Nos.113, 103 and 111. There is a discussion of these prints in Bibliothèque Nationale, *Delacroix et la Gravure romantique,* 1963, pp.7ff. Drawings for Nos.9372 and No.9393 are in the Louvre (see Louvre, *Eugène Delacroix,* 1963, No.320 and Louvre, *Delacroix: Dessins,* 1963, *No.71).* **2.** For the Danson collection see University of Liverpool, *Recorder,* January 1980, No.82, pp.202–205 and Walker Art Gallery, *The Danson Collection of Paintings by Charles Towne,* 1977.

DORAZIO, Piero, born 1927

9249 Olympische Spiele München 1972

Colour offset lithograph, 101×64.1

Signed: (lower right, in the plate) *Piero Dorazio*

Inscribed: *Olympische Spiele München 1972* with Olympic symbol above official emblem of the 20th Olympiad/c *EDITION OLYMPIA 1972 GmbH 1970/Printed in Germany*

See entry for ALBERS, Joseph, No.9243, p.44.

HARTUNG, Hans, born 1904

9250 Olympische Spiele München 1972

Colour offset lithograph, 101×64.1

Signed: (lower right, in the plate) *Hartung*

Inscribed: *Olympische Spiele München 1972* with Olympic symbol above official emblem of the 20th Olympiad/c *EDITION OLYMPIA 1972 GmbH/Printed in Germany*

See entry for ALBERS, Joseph, No.9243, p.44.

KERTESZ, André, born 1894

10382 Joan Lifton, Charles Harbutt and Harold Riley in the Tower Restaurant, Liverpool

Black and white photograph, 20.3×25.3

Inscribed: (verso) *AK*

André Kertész visited the North West of England in July 1980, on the occasion of his exhibition at *Salford '80,* a festival of photographic exhibitions held in a number of art galleries in Salford and Manchester. On July 3rd, a number of photographers present at the festival visited Liverpool, where they dined at the Tower Restaurant; the occasion on which this photograph was taken. The sitters, from left to right, are the American photographers Joan Lifton and Charles Harbutt, who at the time were President and Archivist of the photographic agency *Magnum,* and Harold Riley, the organiser of *Salford '80.* No.10382 was printed from the original negative in 1980 by Igor, Kertész's regular New York printer.[1]

Prov: Presented by Harold Riley, December 1983.

Ref: 1. The above information was provided by Harold Riley, *verbally* 15 December 1983.

KITAJ, R. B., born 1932

9252 Olympische Spiele München 1972

Colour offset lithograph, 101×64.1

Signed: (lower right, in the plate) *Kitaj*

Inscribed: *Olympische Spiele München 1972* with Olympic symbol above official emblem of the 20th Olympiad/c *EDITION OLYMPIA 1972 GmbH 1971/Printed in Germany*

See entry for ALBERS, Joseph, No.9243, p.44.

KOKOSCHKA, Oskar, 1886–1980

9244 Olympische Spiele München 1972

Colour offset lithograph, 101×64.1

Signed: (lower right, in the plate) *O KOKOSCHKA*

Inscribed: *Olympische Spiele München 1972* with Olympic symbol above official emblem of the 20th Olympiad/c *EDITION OLYMPIA 1972 GmbH/Printed in Germany*

See entry for ALBERS, Joseph, No.9243, p.44.

LAPICQUE, Charles, born 1898

9246 Olympische Spiele München 1972

Colour offset lithograph, 101×64.1

Signed: (lower right, in the plate) *Lapicque*

Inscribed: *Olympische Spiele München 1972* with Olympic symbol above official emblem of the 20th Olympiad/c. *EDITION OLYMPIA 1972 GmbH/Printed in Germany*

See entry for ALBERS, Joseph, No.9243, p.44.

LEGROS, Alphonse, 1837–1911

9591 Un Mendiant

Drypoint, 17.5×15.1 (plate)

Signed: *A. Legros* (pencil)

Watermark: *G. and G.*(?)

Only one state of this drypoint is listed by Soulier.[1]

Prov: Purchased from the Boydell Galleries, Liverpool, 1979.

Ref: 1. G. Soulier, *L'Œuvre gravé et lithographié de Alphonse Legros*, 1904, No:287; the subject was a popular one for Legros – see Soulier, *op. cit.* No.236, *Le Mendiant*, No.263, *Beggar with Crutches* and No.403, *Mendiant avec son chapeau à la main.*

9592 Dans les bois

Drypoint, 22.6×15.1 (plate)

Signed: *A. Legros* (pencil)

A second state of this drypoint[1] was in the Frank E. Bliss collection.[2]

Prov: Purchased from the Boydell Galleries, Liverpool, 1979.

Ref: **1.** G. Soulier, *L'Œuvre gravé et lithographié de Alphonse Legros,* 1904, No.341. **2.** Colnaghi and Co., *A Catalogue of Paintings, Drawings, Etchings and Lithographs by Professor Alphonse Legros from the Collection of Frank E. Bliss,* 1922, No.224, p.58.

9768 Paysanne assise près d'une haie

Etching and drypoint, 12.7×17.7 (plate)

Signed: *A.L.* (on plate)

The plate is dated to 1882 by Harold Wright[1] and only one state is listed by Béraldi[2] and Soulier.[3]

Prov: Purchased from the Collectors' Centre, Temple Court, Liverpool.

Ref: **1.** In an MSS Catalogue now at Glasgow University Library. **2.** H. Béraldi, *Les Graveurs du XIX siècle,* Vol.9, 1889, No.241. **3.** G. Soulier, *L'Œuvre gravé et lithographié de Alphonse Legros,* 1904, No.241.

McCARTNEY, Linda, born 1942

9272 Linda's Pictures

Screenprint on mould-made paper 300 gsm, 68×51 (each, sheet size)

Inscribed: (each, in pencil) print series no. *(1—14)* and set no. *(51/150)* and (on title page) *published by MPL Communications Ltd. 1977*

A portfolio, containing a title page and fourteen screenprints (here marked with inventory nos.9272a–9272o). The titles of the individual prints are: 1. *Mick Jagger,* 2. *Brian Jones,* 3. *Grace Slick,* 4. *B. B. King,* 5. *Pete Townshend,* 6. *Cups at EMI studios,* 7. *Boys in Barbados,* 8. *Jimi Hendrix. Blue,* 9. *Wrecked Car,* 10. *David Bowie,* 11. *Painted toenails,* 12. *Mary, Scotland,* 13. *Cinnamon,* 14. *McCartney.*[1] Portfolio number 51 in an edition of 150, plus 15 artist's proofs.

Prov: Presented by the artist, January 1978.

Ref: **1.** The original photographs upon which these screenprints were based are reproduced in Linda McCartney, *Linda's Pictures,* 1976. The concordance between the screenprint numeration in the portfolio and the plate numeration in the book is as follows: 1/1, 2/5, 3/27, 4/30, 5/47, 6/59, 7/62, 8/71, 9/125, 10/85, 11/128/9, 12/135, 13/139, 14/148 and cover.

METZ, Corrado Martino, 1749–1827

9729 Imitations of Ancient and Modern Drawings

Etching and acquatint, 49×34

Inscribed (frontispiece): *IMITATIONS OF ANCIENT AND MODERN DRAWINGS ENGRAVED AND PUBLISHED BY C. M. METZ; LONDON., MDCCLXXXIX*

A portfolio of etchings, some with aquatint, after drawings attributed to Barocci, Bernini, Ludovico Cangiagio, Annibale and Lodovico Carracci, Carlo Cignani, Correggio, Daniele da Volterra, Domenichino, Albrecht Dürer, Paolo Farinati, Battista Franco, Benvenuto Garofalo, Giulio Romano, Guercino, Raymond Lafage, Leonardo da Vinci, Michelangelo, Palma Giovane, Parmigianino, Perino del Vaga, Polidoro da Caravaggio, Primaticcio, Raffaelo da Reggio, Raphael, Guido Reni, Tintoretto, Titian, Giorgio Vasari and Taddeo Zuccaro in the collections of Henry Beverley, Richard Cosway, Richard Dalton, the Marchese Gentili, Sir Abraham Hume, King George III, Edward Knight, Richard Payne Knight, Sir Joshua Reynolds, Paul Sandby, Robert Udney and Benjamin West. In all, 80 prints after 104 drawings, together with a frontispiece. Each print bears a caption with the names of the artist and the owner and many are signed in the plate *CM Sc.* or *CMM Sc.* Some of the prints are dated in the plate 1789 and others 1790. The address of Metz is also given on some, as Upper Berkley Street, Portman Square. There is a duplicate of No.9729 in the Department of Prints and Drawings, the British Museum (Shelf Mark 164 c5). Metz issued other portfolios of etchings after old master drawings in 1790, 1791 and 1798.[1]

Prov: Christie's Sale, 15 February 1980 (18) bt. for Walker Art Gallery.

Ref: 1. U. Thieme and F. Becker, *Allgemeines Lexikon der Bildenden Künstler*, vol.24, 1930, p.443.

SOULAGES, Pierre, born 1919

9256 Olympische Spiele München 1972

Colour offset lithograph, 101×64.1

Signed: (lower right, in the plate) *Soulages*

Inscribed: *Olympische Spiele München 1972* with Olympic symbol above official emblem of the 20th Olympiad/c *EDITION OLYMPIA 1972 GmbH 1970/Printed in Germany*

See entry for ALBERS, Joseph, No.9243, p.44.

VASARELY, Victor, born 1908

9245 Olympische Spiele München 1972

Colour offset lithograph, 101×64.1

Signed: (lower right, in the plate) *Vasarely*

Inscribed: *Olympische Spiele München 1972* with Olympic symbol

above official emblem of the 20th Olympiad/c *EDITION OLYMPIA 1972 GmbH 1970/Printed in Germany*

See entry for ALBERS, Joseph, No.9243, p.44.

VILLOT, Frédéric, 1809–1875, after DELACROIX, Ferdinand Victor Eugene, 1798–1863

9374 Monk at prayer

Etching, 10.7×18.8 (plate size)

Inscribed: *Eug. Delacroix del. Fréd Villot sculp. 1843/Delâtre frères imprs.*

This etching was made after a drawing of about 1821 by Delacroix recorded at the Frédéric Villot Sale, Paris, 11 February, 1865 (lot 35)[1] and now in the Walters Art Gallery, Baltimore.

Prov: Colonel Raymond C. Danson[2]; presented by Iain Campbell 1978.

Ref: **1.** A. Robaut, *L'Œuvre Complet de Eugène Delacroix*, 1885, p.13, No.34. **2.** See above p.49 under Delacroix for details about this collector.

WESSELMANN, Tom, born 1931

9257 Olympische Spiele München 1972

Colour offset lithograph, 101×64.1

Signed: (lower right, in the plate) *Wesselmann 70*

Inscribed: *Olympische Spiele München 1972* with Olympic symbol above official emblem of the 20th Olympiad/c *EDITION OLYMPIA 1972 GmbH 1971/Printed in Germany*

See entry for ALBERS, Joseph, No.9243, p.44.

WHISTLER, James Abbott McNeill, 1834–1903

9772 The Velvet Dress

Drypoint on thin Japan paper, 23.4×15.5 (plate size)

Signed: with butterfly (on plate)

Second State.[1] The first of the two drypoint portraits of Mrs. Florence Leyland both made in 1873.[2] Mrs. Florence Leyland, daughter of Thomas Dawson, married Frederick Leyland in 1855; she was born in 1834 and died in 1910. Whistler did an oil painting of her between 1871 and 1874 (now Frick Collection, New York)[3] in which she wanted to

pose[4] in a black velvet dress similar to that worn by Mrs. Louis Huth for her portrait of 1872–1874 (now Viscount Cowdray Collection)[5]; perhaps in No.9772 she is wearing that black velvet dress.[6]

Prov: H. H. Benedict[7]; A. H. Hahlo and Co.[8]; Mrs. Diego Suarez sold Christie's New York, 2 May 1980, lot 450 bought Agnew and David Turnick 8250 dollars for the Walker Art Gallery.

Ref: **1.** E. G. Kennedy, *The Etched Work of Whistler,* 1910, No.105. **2.** Thomas Agnew and Sons, *Whistler, The Graphic Work,* 1976, No.63, p.32. **3.** A. McLaren Young and others, *The Paintings of James McNeill Whistler,* 1980, No.106, pp.65–66. **4.** E. R. and J. Pennell, *The Whistler Journal,* 1921, pp.101–102. **5.** Young, *op. cit.,* No.125, pp.75–76. **6.** As implied in Thomas Agnew, *op. cit.* **7.** His stamp (F. Lugt, *Les Marques de Collections,* 1921, p.230, No.1298) appears indistinctly on No.9772. **8.** Lugt, *op. cit.,* pp.542–543, No.2936.

WINTER, Fritz, born 1905

9259 Olympische Spiele München 1972

Colour offset lithograph, 101×64.1

Signed: (lower right, in the plate) *FW* (? indistinct)

Inscribed: *Olympische Spiele München 1972* with Olympic symbol above official emblem of the 20th Olympiad/c *EDITION OLYMPIA 1972 GmbH/Printed in Germany*

See entry for ALBERS, Joseph, No.9243, p.44.

NUMERICAL INDEX

(P) denotes paintings, (D) denotes drawings and watercolours, (E) denotes prints and photographs, (S) denotes sculpture

1537–1539	(P)	Fuseli	9448	(S)	Robbia
1540	(D)	Fuseli	9458–9459	(S)	Robbia
2620	(P)	Adam	9466	(S)	Girardon
2664–2665	(P)	Adam	9474	(S)	Robbia
3224	(D)	Salome	9477	(S)	Robbia
8642	(D)	Salome	9478	(S)	Duquesnoy
8829	(D)	Fuseli	9508	(S)	Verrochio
9243	(E)	Albers	9523	(P)	Tissot
9244	(E)	Kokoschka	9591–9592	(E)	Legros
9245	(E)	Vasarely	9720	(E)	Baugniet
9246	(E)	Lapicque	9725	(S)	Dupuis
9248	(E)	Antes	9729	(E)	Metz
9249	(E)	Dorazio	9738–9740	(D)	Wilczynski
9250	(E)	Hartung	9743–9754	(E)	Cartier-Bresson
9251	(E)	D'Arcangelo	9768	(E)	Legros
9252	(E)	Kitaj	9772	(E)	Whistler
9253	(E)	Bill	9785–9788	(D)	Gruber
9255	(E)	Alt	9833	(D)	Signorelli
9256	(E)	Soulages	9864	(P)	Joos
9257	(E)	Wesselmann	9880–9885	(D)	Piola
9258	(E)	Chillida	9886	(D)	Italian School
9259	(E)	Winter	10242–10243	(P)	Laszlo
9260	(E)	Arakawa	10245	(P)	Diest
9272	(E)	McCartney	10255	(D)	Salome
9273	(P)	Gotlib	10296	(P)	Lipczinsky
9274–9280	(D)	Gotlib	10329	(P)	Elsheimer
9282	(D)	Bolognese School	10333–10334	(S)	Italian School
9300	(E)	Delacroix	10335	(S)	Este
9327	(D)	Westhofen	10336–10337	(S)	Italian School
9340	(D)	Westhofen	10338	(S)	Cavaceppi
9342	(D)	Martino	10339	(S)	Italian School
9344	(D)	Westhofen	10340	(S)	Cavaceppi
9348	(D)	Steiger	10341–10342	(S)	Italian School
9372	(E)	Delacroix	10344–10348	(S)	Italian School
9374	(E)	Villot	10350	(P)	Poussin
9375	(P)	Montagna	10361	(S)	Kapoor
9393	(E)	Delacroix	10382	(E)	Kertesz

GENERAL INDEX

PAINTINGS

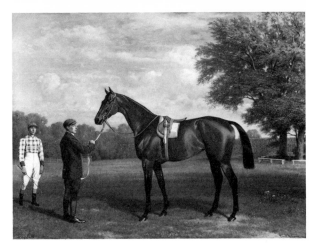

ADAM, Emil, born 1843
2620 Cherry Lass

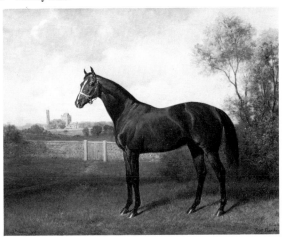

ADAM, Emil, born 1843
2664 Count Schomberg

ADAM, Emil, born 1843
2665 Mulberry

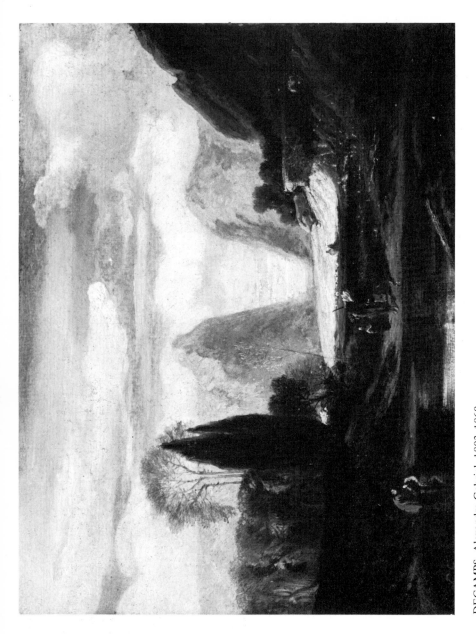

DECAMPS, Alexandre Gabriel, 1803–1860
L 43 Eastern Landscape with Figures and Rider on a Camel

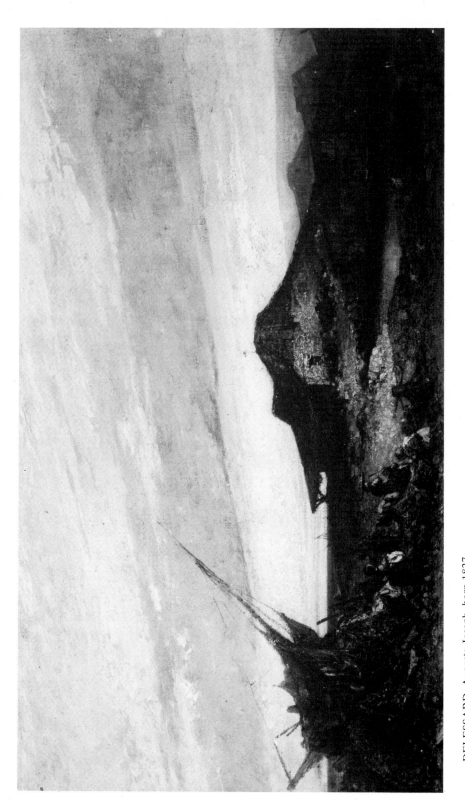

DELESSARD, Auguste Joseph, born 1827
L 40 **House on the Shore, with figure by grounded boat**

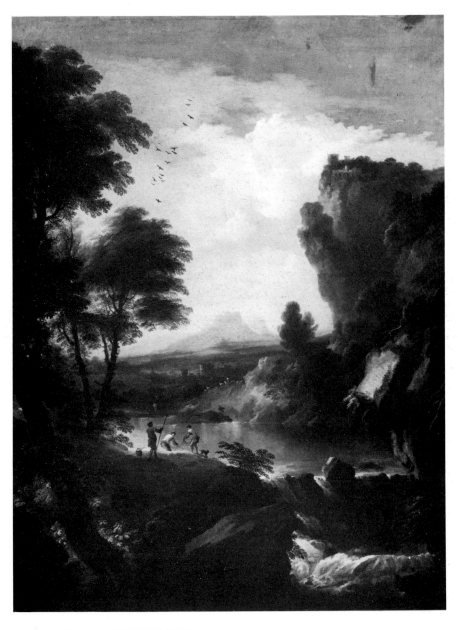

DIEST, Adriaen van, 1655/1656–1704
10245 Landscape with waterfall

ELSHEIMER, Adam, 1578–1610
10329 Apollo and Coronis

FUSELI, John Henry, 1741–1825
1537 **Death of Oedipus**

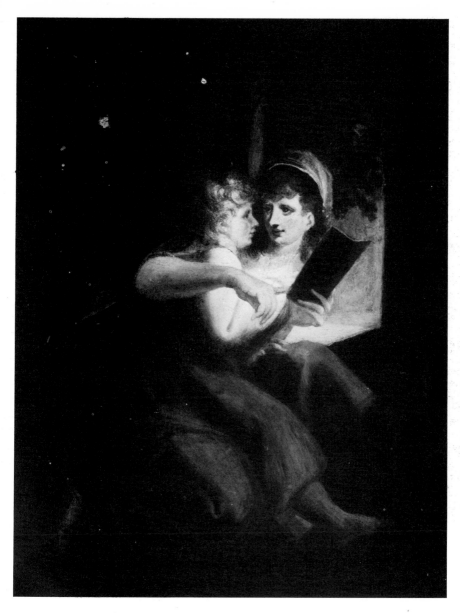

FUSELI, John Henry, 1741–1825
1538 Milton when a boy instructed by his Mother

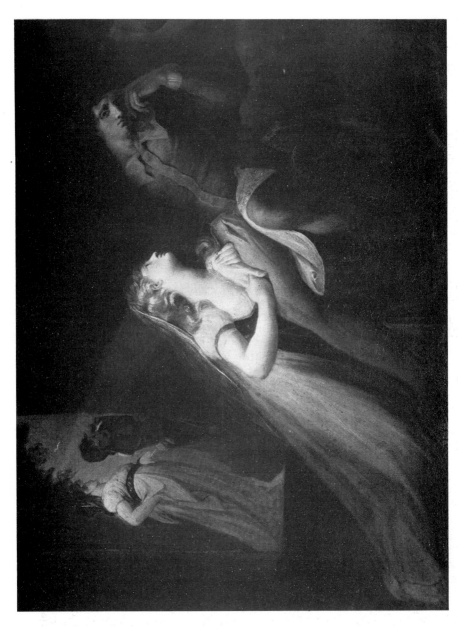

FUSELI, John Henry, 1741–1825
1539 The Return of Milton's Wife

GOTLIB, Henryk, 1890–1966
9273 Italian Landscape with Woman, Child and Dog

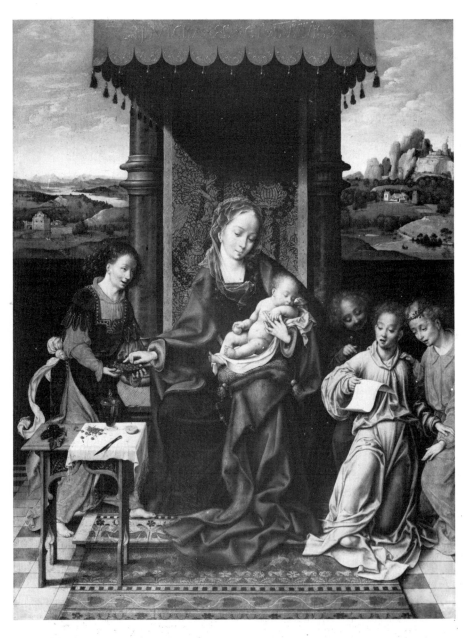

JOOS van Cleve, active 1511–1540/41
9864 The Virgin and Child with Angels

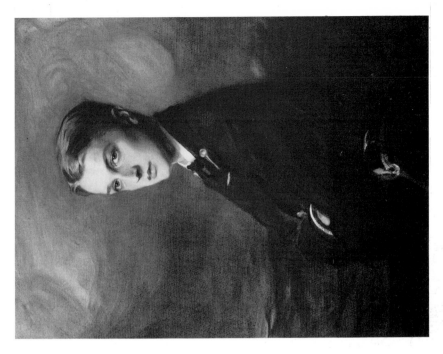

LASZLO, Philip Alexius de, 1869–1937
10243 Hon. Cecil Richard Molyneux (1899–1916)

LASZLO, Philip Alexius de, 1869–1937
10242 Hugh William Osbert Molyneux, 7th Earl of Sefton (1898–1972)

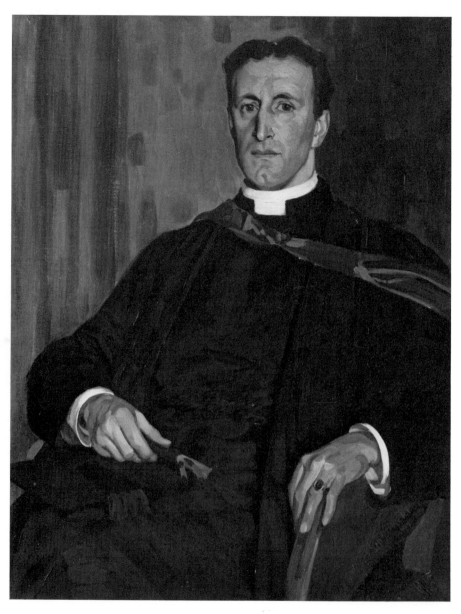

LIPCZINSKY, Albrecht, 1875–1974
10296 Canon J. T. Mitchell (1863–1947)

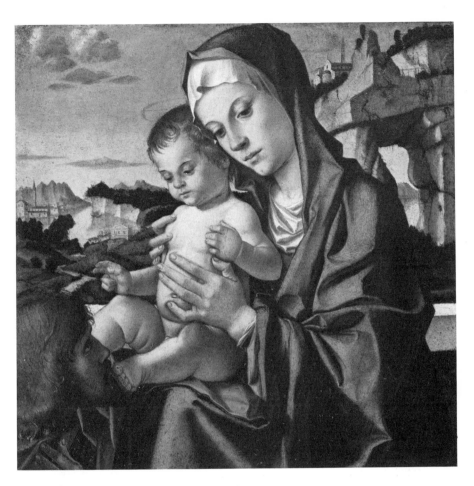

MONTAGNA, Bartolomeo, *c.*1440–1523
9375 The Virgin and Child with a Saint

POUSSIN, Nicolas, 1593/4–1665
10350 Landscape with the Ashes of Phocion

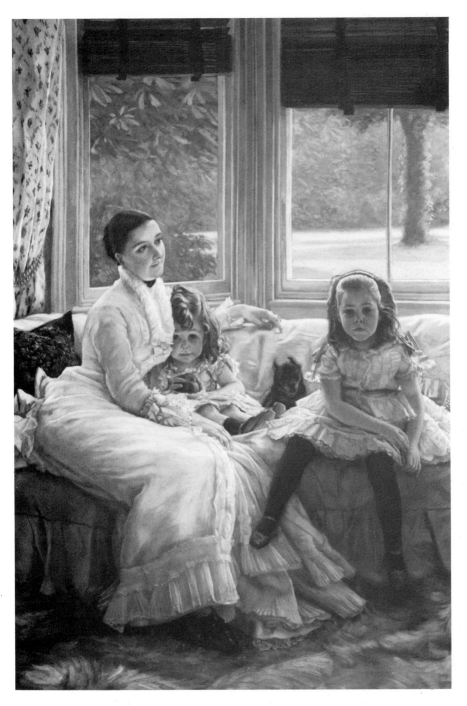

TISSOT, James Jacques Joseph, 1836–1902
9523 Catherine Smith Gill and two of her children

DRAWINGS
AND
WATERCOLOURS

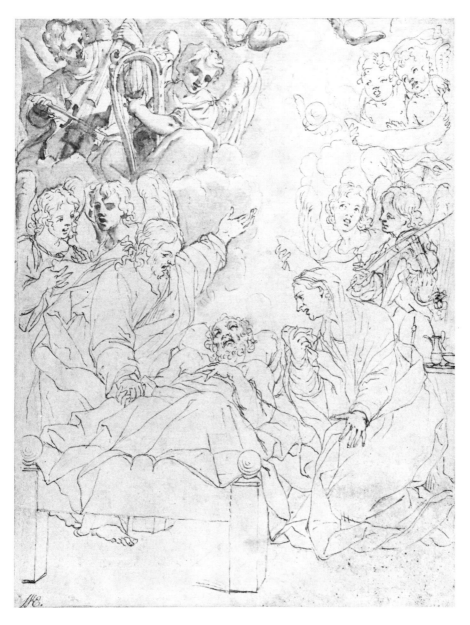

BOLOGNESE School, early 17th century
9282 Death of Saint Joseph

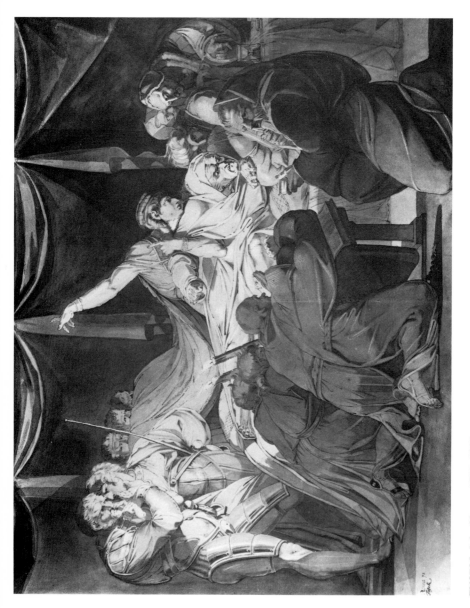

FUSELI, John Henry, 1741–1825
1540 Death of Cardinal Beaufort

84

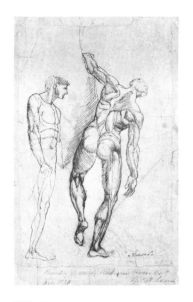

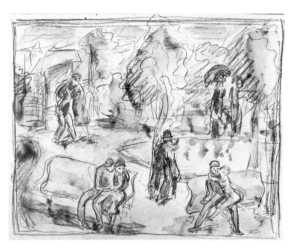

GOTLIB, Henryk, 1890–1966
9274 Couples in Love in a Park

FUSELI, John Henry, after
**8829 Study of Naked Athletes, one
 seen from behind**

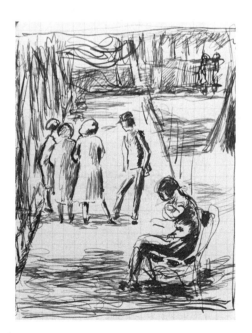

GOTLIB, Henryk, 1890–1966
9276 Woman Sitting in an Armchair

GOTLIB, Henryk, 1890–1966
9275 A Scene in a Park

85

GOTLIB, Henryk, 1890–1966
9277 Portrait of a Woman with Hands Clasped

GOTLIB, Henryk, 1890–1966
9278 Portrait of a Woman

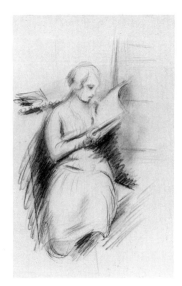

GOTLIB, Henryk, 1890–1966
9279 A Kneeling Figure with an Umbrella

GOTLIB, Henryk, 1890–1966
9280 Woman Reading a Book

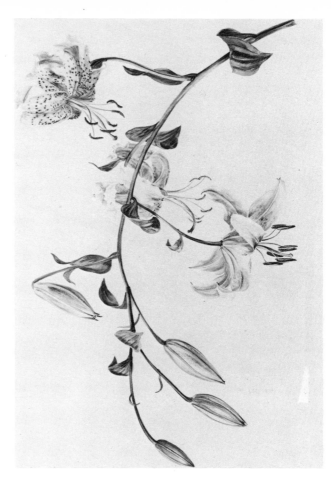

GRUBER, Karl Franz, 1803–1845
9786 Martagon Lily (Lilium martagon)

GRUBER, Karl Franz, 1803–1845
9785 Botanical Studies

GRUBER, Karl Franz, 1803–1845
9788 Botanical Studies

GRUBER, Karl Franz, 1803–1845
9787 Botanical Studies

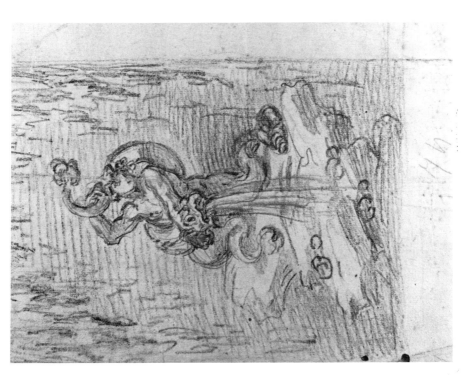

MARTINO, Eduardo de, 1838–1912
9342 River Scene with Boat

ITALIAN School, 18th century
9886 Study of a Fountain

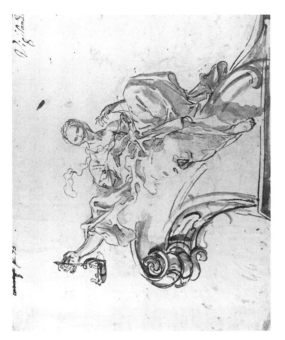

PIOLA, Paolo Gerolamo, 1666–1724
9882 Vigilance

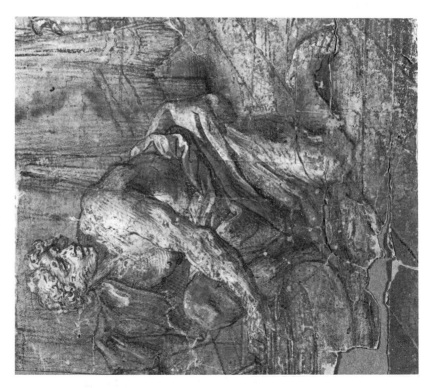

PIOLA, Paolo Gerolamo, 1666–1724
9880 Study of a man kneeling by a jar

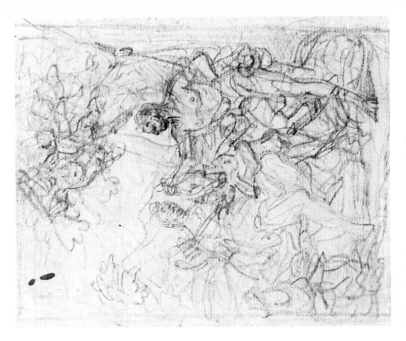

PIOLA. Paolo Gerolamo, 1666–1724
9885 Atalanta and Meleager

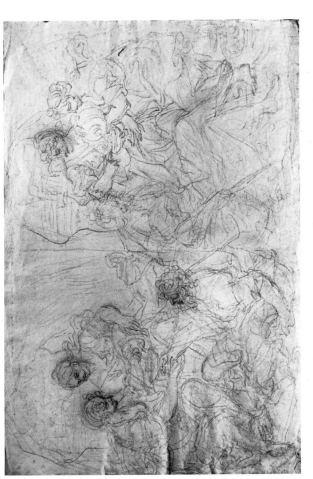

PIOLA, Paolo Gerolamo, 1666–1724
9884 Two studies of Lot and his Daughters

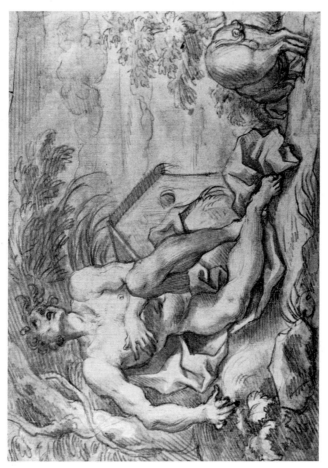

PIOLA, Paolo Gerolamo, 1666–1724
9883 The Prodigal Son

PIOLA, Paolo Gerolamo, 1666–1724
9881 Apollo Flaying Marsyas

SALOMÉ, Antoine de or SOLOMÉ, Anton,
active 1835–1872
3224 George Melly

SALOMÉ, Antoine de or SOLOMÉ, Anton,
active 1835–1872
8642 Cecil Emily, Countess of Sefton

SALOMÉ, Antoine de or SOLOMÉ, Anton,
active 1835–1872, after
8642 Cecil Emily, Countess of Sefton

SIGNORELLI, Luca, 1441–1523
9833 Study of a Young Man

94

STEIGER, Isabel de, active 1879–1926
9348 Arabs in an alcove

WESTHOFEN, W., active late 19th century
9327 Country Lane with Figure

WESTHOFEN, W., active late 19th century
9340 Fir-lined river near mountains

WESTHOFEN, W., active late 19th century
9344 River Scene by Moonlight

WILCZYNSKI, Katerina, 1894–1978
9739 San Francisco Acatepec

WILCZYNSKI, Katerina, 1894–1978
9738 Sepulveda

WILCZYNSKI, Katerina, 1894–1978
9740 Delphi, hills

96

SCULPTURE

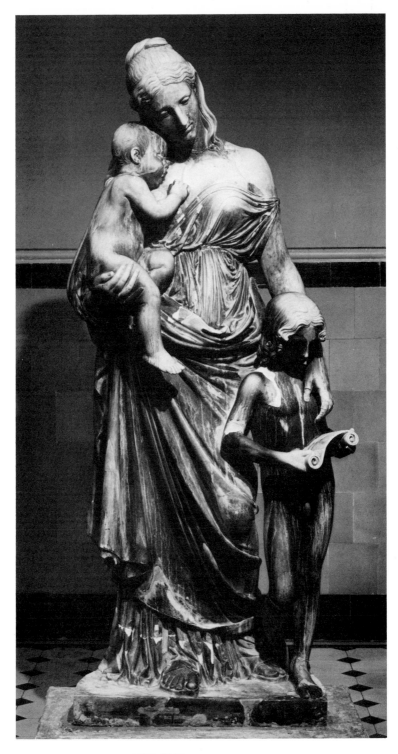

BARTOLINI, Lorenzo, 1777–1850
L679 Charity

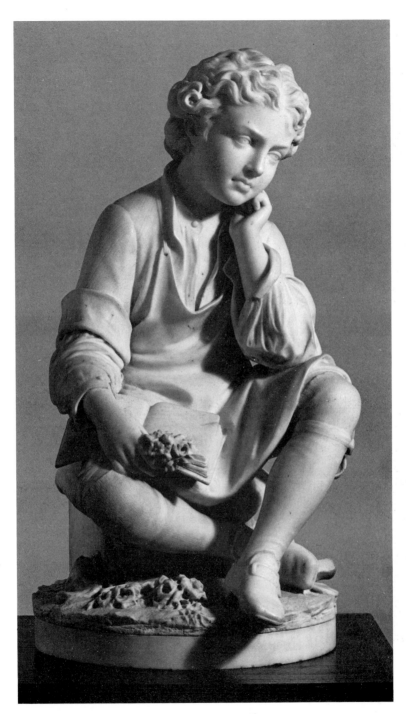

BAZZANTI, P. & Co., mid 19th century
L447 The Young Linnaeus

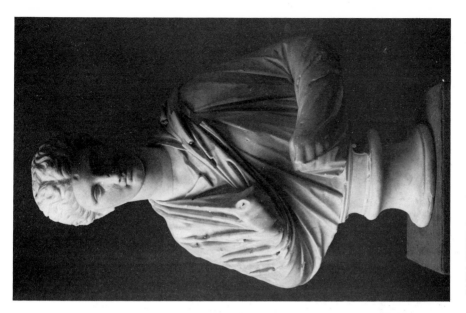

CAVACEPPI, Bartolomeo, 1716–1799
10340 Bust of a Woman

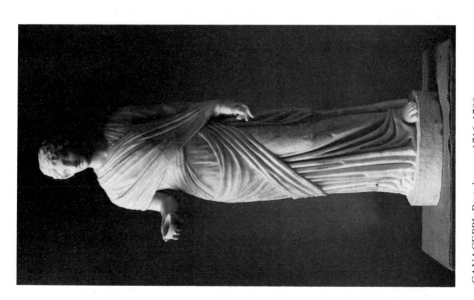

CAVACEPPI, Bartolomeo, 1716–1799
10338 Statuette of a Muse

DUPUIS, Jean Baptiste Daniel, 1849–1899, after
**9725 Medal of the Société des artistes français
(obverse)**

DUPUIS, Jean Baptiste Daniel, 1849–1899, after .
**9725 Medal of the Société des artistes français
(reverse)**

DUQUESNOY, François, 1594–1643, after
9478 Musical Putti

GIRARDON, François, 1628–1715, after
9466 Allegorical Figure

ESTE, Antonio d', 1754–1837
10335 Bust of Claudius

103

ITALIAN school, 18th century
10336 Bust of the Emperor Caracalla

ITALIAN School, 18th century
10333 Bust of Julius Caesar

104

ITALIAN school, 18th century
10337 Bust of Homer

ITALIAN school, 18th century
10339 Bust of a Woman with a Veil

ITALIAN school, 18th century
10342 Female Hand

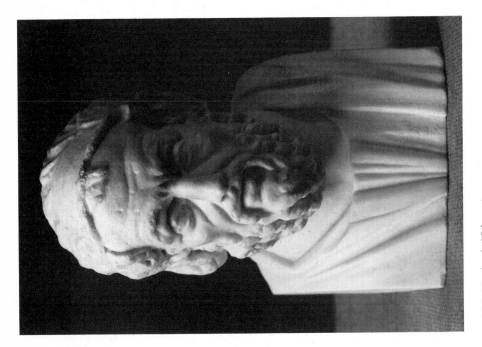

ITALIAN school, 18th century
10341 Bust of Homer

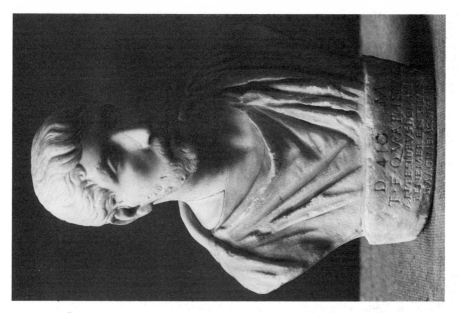

ITALIAN school, 18th century
10345 Bust of Quintus Aristaeus

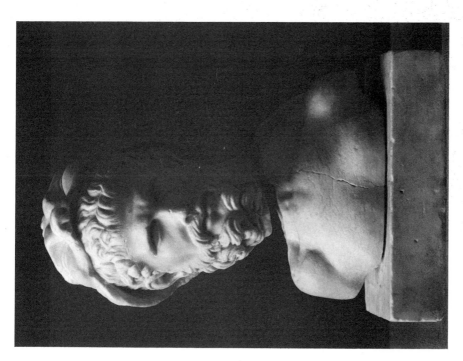

ITALIAN school, 18th century
10344 Head and shoulders of Hercules

107

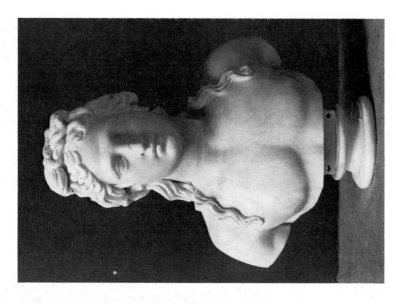

ITALIAN school, 18th century
10347 Bust of Apollo or Venus

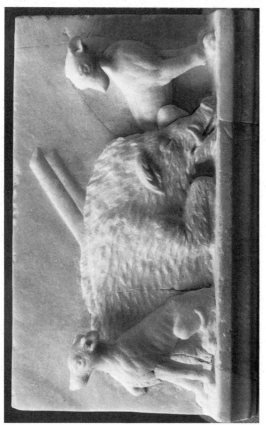

ITALIAN school, 18th century
10346 Boar and two dogs

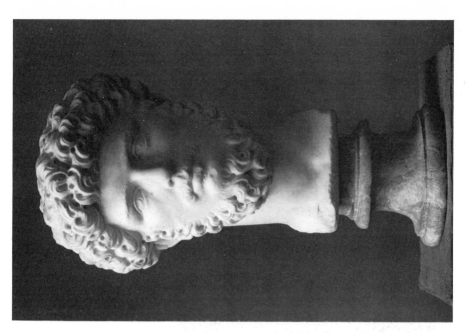

ITALIAN School, 18th or 19th century
10334 Head of Lucius Verus

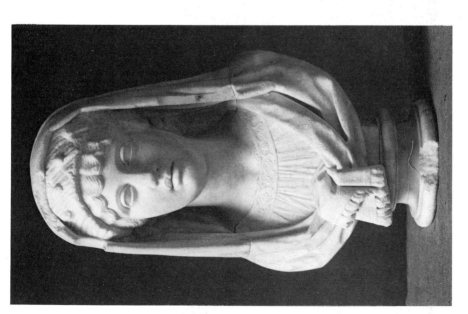

ITALIAN school, 18th century
10348 Bust with double veil

109

KAPOOR, Anish, born 1954
10361 Red in the Centre

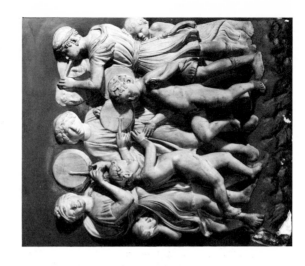

ROBBIA, Luca della, 1400–1482, after
9477 Drummers and Dancing Children

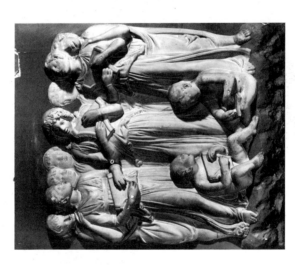

ROBBIA, Luca della, 1400–1482, after
9458 Players on the Psaltery

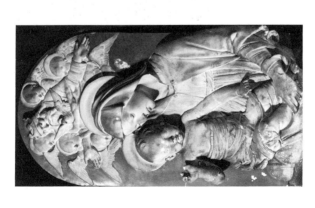

ROBBIA, Andrea della,
1435–1525, after
**9448 Madonna and Child with
God the Father, the Holy Ghost
and angels**

111

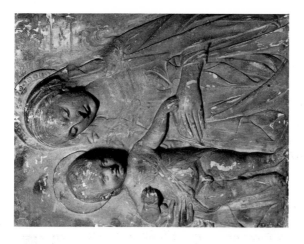

VERROCCHIO, Andrea del, c. 1435–1488, after
9508 Madonna and Child

ROBBIA, Luca della, 1400–1482, after
9459 Players on the Cithera

ROBBIA, Luca della, 1400–1482, after
9474 Trumpeters and Dancing Children

APPENDIX

MISTRY, Dhruva, born 1957
10397 Sitting Bull

Plaster with yellow-ochre polychromy, 31×39.5×23.5

Inscribed: (inside) *DHRUVA MISTRY 83*

One of a series of statues of sitting bulls executed in 1983–84. The two earliest are smaller than the present work, and a fourth, larger piece was exhibited in the Peter Moores Liverpool Project 7: *As of Now*.[1] No.10397 is a maquette for the monumental statue executed for the 1984 Liverpool Garden Festival.[2] Like a number of sculptures of other animals by the artist,[3] No.10397 is informed by Indian mythology, and is derived from the bull Nandi, a familiar of the Hindu god Shiva. Its non-naturalistic colouring was intended partly to inhibit a too literal identification of the sculpture with the animal which it portrays and partly to emphasise its sense of presence. In the Western tradition, the bull has traditional associations of strength and power,[4] which also find expression in No.10397. Like Landseer's statues of lions, the present work may more aptly be interpreted as an image of composed strength, than as a specific national symbol. In this respect, it is noteworthy that the artist has characterised his intentions thus: 'I wanted to make a bull which would make a tiger run away'.

Prov: Presented by the Friends of the Merseyside County Museums and Art Galleries, 1984.

Ref: **1.** The two earliest examples are of polychromed plaster and of carved chalk coated with shellac and polychromy., The former is in the Indian Section of the Victoria and Albert Museum and the latter is in the collection of William Feaver. For the larger version (cement and sand with polychromy, 122×71×104 cm.), in the Peter Moores Foundation, see the exhibition catalogue *As of Now*, Walker Art Gallery, Liverpool, 24 November 1983–19 February 1984. **2.** The monumental version, which gives its name to the Nandi Garden in the Garden Festival is currently (April 1984) in course of execution. Of polychromed concrete on metal armature, its approximate dimensions are 10×11×8 ft. The incised lines on No.10397 indicate the position of the armature in the monumental version. The following discussion is based in part upon conversations with the artist on 27 March and 5 April 1984. **3.** See, for example, the statues *Tipu* 1982 and *Creature* 1983, both in the exhibition *As of Now*. **4.** Not only in the paintings and prints of Goya and Picasso, but also in much earlier works, such as Michael Pacher's *Ox of St. Luke* of *c*.1470/80, for which see G. Biedermann, *Katalog der mittelalterlichen Kunst,* Alte Galerie am Landesmuseum Joanneum, Graz 1982, pp.114–115 and pl.37.

MISTRY, Dhruva, born 1957
10397 Sitting Bull